IMAGES
of America

AROUND
YAVAPAI COUNTY

CELEBRATING ARIZONA'S CENTENNIAL

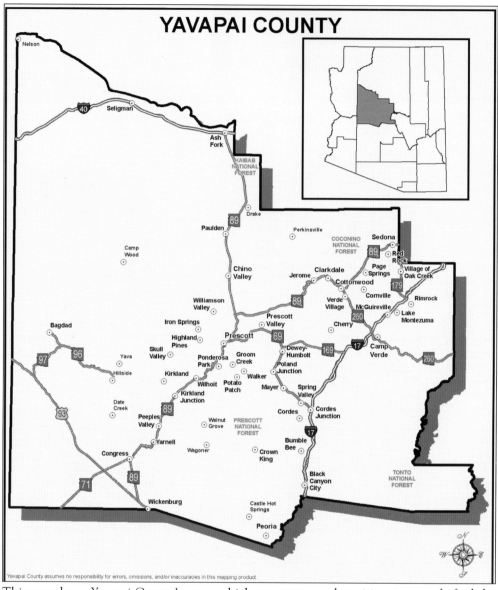

This map shows Yavapai County's current highway system so that visitors can easily find the cities, towns, and rural areas that are featured in this book. (Courtesy of Yavapai County MIS Department.)

ON THE COVER: The Yavapai County Arizona Centennial Committee is grateful to the Sharlot Hall Museum for the use of many photographs in this book, including the vintage image of the Yavapai County Courthouse in Prescott on the cover.

IMAGES
of America

AROUND
YAVAPAI COUNTY

CELEBRATING ARIZONA'S CENTENNIAL

Nancy Burgess and Karen Despain
on behalf of the Yavapai County
Arizona Centennial Committee

ARCADIA
PUBLISHING

Published by Arcadia Publishing
Charleston, South Carolina

Printed in the United States of America

Library of Congress Control Number: 2011925558

For all general information, please contact Arcadia Publishing:
Telephone 843-853-2070
Fax 843-853-0044
E-mail sales@arcadiapublishing.com
For customer service and orders:
Toll-Free 1-888-313-2665

Visit us on the Internet at www.arcadiapublishing.com

CONTENTS

ACKNOWLEDGMENTS

Editors and authors Nancy Burgess and Karen Despain wish to acknowledge all of the hard work of the caretakers of our Arizona history: the professional and amateur historians, the collectors, historical societies, museums and their staffs and volunteers, and all of those Arizonans who strive daily to rescue, retain, protect, and conserve Arizona's most fascinating and diverse history. Without these people, our history would be lost or hidden away, and the stories of our past would never be told.

Ash Fork, Beaver Creek, Rimrock and Lake Montezuma, Bagdad, Camp Verde, Chino Valley, Clarkdale, Congress, Cordes Station, Cottonwood, Crown King, Dewey-Humboldt, Jerome, Mayer, Prescott, Prescott Valley, the Prescott National Forest, the Yavapai-Prescott and Yavapai-Apache tribes, Sedona, Seligman, and Skull Valley—all of these communities, large and small, are represented in *Around Yavapai County: Celebrating Arizona's Centennial*. Hopefully, all of these communities will be participating in some way in the state's centennial and, hopefully, this book will inspire our readers to get out and explore this great county and all of the things there are to learn, see, and do in celebrating Arizona's 100th anniversary. In doing so, we hope that residents and visitors alike to Yavapai County will come away with a better understanding and appreciation for the intrinsic value of our history and its effect on the lives of all Arizonans.

We wish to thank each and every person who contributed to this effort: the authors, including Parker Anderson, Steve Ayers, Dewey Born, Bill Cowan, Kelly Cordes, Jean Cross, Jim Eaton, Michael King, Anthony Nelson and the Crown King Historical Society, Vincent Randall and Rita Wuehrmann; the community members who gave of their time, memories, and photographs; and the historical societies and museums that provided additional information and images. Without all of you, this project would not have been possible. You are truly the caretakers of our history.

All images in this book are from the private collection of Nancy Burgess unless otherwise credited. Real-photo postcards are identified as RPPC.

INTRODUCTION

The history of Yavapai County is rich and vast, fully deserving of preservation for future generations. Yavapai County has the quintessential history of cowboys and Indians, miners and merchants, and shady ladies.

The Yavapai County Arizona Centennial Committee was created by the Yavapai County Board of Supervisors in January 2009. As a part of its purpose, the committee is to identify and assist with the development of projects focused on history and the Arizona centennial that bring attention to and participation from all parts of Yavapai County. *Around Yavapai County: Celebrating Arizona's Centennial* is one of the Centennial Committee's projects. We hope this book will encourage both residents and visitors to learn and appreciate the rich history of Yavapai County and to enjoy the spectacular scenery and historical places, together with the people and local characters who have made Yavapai County what it is today.

The first known Anglo visitors to our area were Spanish explorers seeking gold and silver during the 16th and 17th centuries. Unlike in other parts of the Southwest, the Spanish adventurers had very little cultural impact in central and northern Arizona. Mountain men and trappers began exploring the area in the 1820s. The Treaty of Guadalupe Hidalgo brought the New Mexico Territory, including what became the Arizona Territory, into the United States in 1848.

In 1886, the Santa Fe, Prescott & Phoenix Railway (SFP&P) arrived in Prescott, and it later continued on to Phoenix with connections to other parts of the territory. The railroads and modern highways, which replaced the old dusty, muddy, and rutted wagon and stagecoach roads, brought people to Yavapai County. Many travelers stopped, explored, and stayed or returned.

The Arizona Organic Act, signed by President Lincoln, created the Arizona Territory, previously the western portion of the New Mexico Territory, as an official US territory on December 29, 1863. The new Arizona Territory was created with only four counties: Mohave, Pima, Yavapai, and Yuma. The county names reflected some of the Native American peoples who inhabited the areas.

As one of Arizona's original counties, Yavapai consisted of approximately 65,000 square miles and is believed to have been the largest county ever created in the United States. Yavapai County is known as the "Mother of Counties" because all or portions of five other counties —Apache, Coconino, Gila, Maricopa, and Navajo—were carved out of the original area of Yavapai. Today, Yavapai County consists of 8,125 square miles, which is similar in size to the state of Massachusetts.

The territorial capital was established at Prescott in May 1864. The capital moved to Tucson for 10 years (1867–1877) before being returned to Prescott for a period of 12 years. In 1889, Phoenix became the permanent capital of the Arizona Territory, and later, the State of Arizona.

The first Territorial Governor's Mansion, built in 1864, still stands in its original location and is open to the public on the grounds of the Sharlot Hall Museum in Prescott. The museum is named for Sharlot Mabridth Hall, the first official historian of the Arizona Territory and the first woman to hold an official government post in Arizona Territory.

The residents of Arizona Territory lobbied Congress for statehood for more than 40 years. In December 1911, territorial governor Richard Sloan sent a letter to Pres. William Howard Taft asking to have the statehood proclamation for Arizona signed on February 12, Abraham Lincoln's birthday. Sloan's request to have the proclamation signed was granted, but the date of the signing was delayed. Finally, on February 14, 1912, President Taft signed the Arizona Statehood Act with a delegation of dignitaries from the Arizona Territory present. Thus, the "Valentine State" was ushered into the union, making Arizona the 48th, and final, contiguous state of the continental United States of America.

Since statehood, Yavapai County, with Prescott as the county seat, has continued to prosper and grow. The City of Prescott's airport, Ernest A. Love Field, which is named for one of Prescott's World War I fliers, was dedicated in August 1928. Today, it is one of the busiest airports in Arizona. No matter what the reason for coming to Yavapai County, its people have been hardworking and independent. Without their efforts, the county would not be what it is today.

The communities in Yavapai County are numerous and diverse, and each one has a unique location and offers enriching opportunities, activities, and experiences. Today, tourism plays a major role in the economy and the sustainability of the county. Historic and prehistoric sites abound, with approximately 1,000 buildings (including the Yavapai County Courthouse), structures (such as bridges and a windmill), sites (such as archaeological sites), and objects (a clock and streetlamps) listed in the National Register of Historic Places. Prescott is a Preserve America Community, and Jerome is a national historic landmark. The Sedona Historical Society, at the historic Jordan Ranch, is a great place to see and learn local history. The mining towns of Jerome and Clarkdale, as well as the ancient American Indian ruins at Tuzigoot Pueblo, Montezuma Castle, and Montezuma Well, draw thousands of visitors every year. Arcosanti attracts visitors from all over the world to Paolo Soleri's "utopian" community. Local, regional, and state parks, along with national monuments and spectacular scenery, provide visitors and residents with an amazing amount of civic and heritage tourism opportunities.

The arts are an integral part of Yavapai County. Many communities celebrate arts and culture with museums, theaters, galleries, concerts, shows, resident artist studio tours, public art, and festivals.

The communities described in this book offer their own unique histories, activities, locations, and attractions. We have highlighted each of the incorporated cities and towns of Camp Verde, Chino Valley, Clarkdale, Cottonwood, Dewey-Humboldt, Jerome, Prescott, Prescott Valley, and Sedona. Much of our rich history and colorful past still lives in the unincorporated communities of Ash Fork, Beaver Creek, Rimrock and Lake Montezuma, Bagdad, Black Canyon City, Congress, Cordes Station, Crown King, Mayer, Seligman, and Skull Valley . The Yavapai-Prescott and the Yavapai-Apache Indian tribes have been included to highlight their special histories and cultural contributions to Yavapai County. Finally, the Prescott National Forest, with approximately 1.25 million acres within Yavapai County, is featured as one of the largest natural resources and recreational facilities within the county.

While each and every community cannot be included in this publication, each location, town, and community within Yavapai County, whether included or not, has its own significant history, colorful characters, folklore, and natural attractions. Yavapai County is home to much of Arizona's most interesting history, spectacular scenery, and outdoor recreational opportunities. You will be richly rewarded for your interest, research, and personal visit to Yavapai County. We invite you to come share, explore, and enjoy Yavapai County with us as we celebrate Arizona's centennial!

—Janis Ann Sterling

One

A Driving Tour

Around Yavapai County

After one of the longest-running efforts in territorial history, Congress finally passed the bill in January 1910 that gave Arizona and New Mexico separate statehood. All over Arizona, people celebrated, unaware that there was a big battle yet ahead. In mid-1910, Pres. William Howard Taft approved legislation allowing Arizona Territory voters to elect 52 delegates to a constitutional convention. In a 60-day session marked by prodigious work and flared tempers, the resulting Arizona Constitution was considered to be one of the most radical of all state charters. After a lengthy conflict between President Taft and the drafters of the Arizona Constitution, Taft finally signed the statehood bill on February 14, 1912, and Arizona became the "Valentine State."

Statehood and progress went hand in hand, and progress was underway around Yavapai County. The population grew. Foot trails became roads. The railroads arrived. Roads began to be used by a newfangled "machine," the automobile. Everyone worked hard, but travel was easier, and goods and services were more readily available. Mining, ranching, and farming led the way economically, with tourism beginning to be an important factor. Railroads offered discounted fares to people who would come to the newly "civilized" state of Arizona.

Today, the Yavapai County Arizona Centennial Committee invites the reader to an adventure: to become a tourist in Yavapai County, to visit its communities and scenic places, and to appreciate its history.

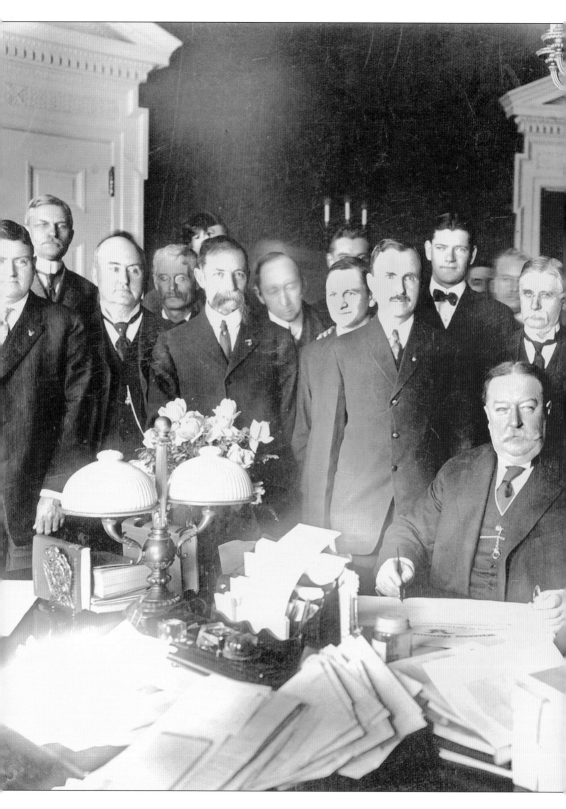

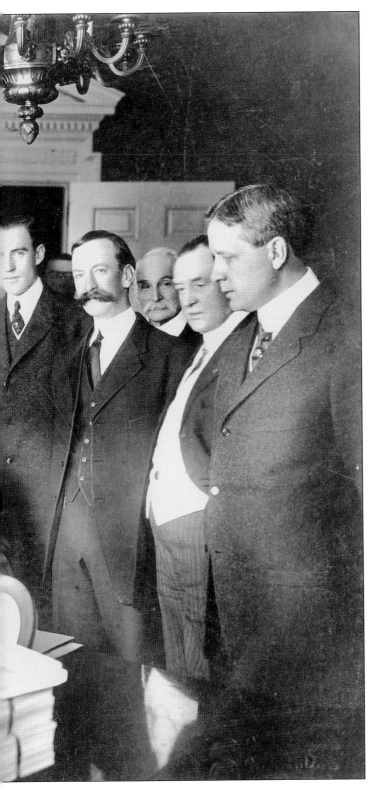

Pres. William Howard Taft signs the bill granting Arizona admission to the union as the nation's 48th state. Standing immediately to the president's right is Ralph Henry Cameron, the last Arizona territorial delegate to the US House of Representatives. In 1912, many Arizonans regarded Cameron as the hero of statehood and gave him the credit for finally bringing it about. Today, however, statehood historians discount his role and seldom, if ever, mention Cameron's name. This may partly be due to the negative reputation he incurred for keeping the US government tied up in court for many years with lawsuits trying to prevent the Grand Canyon from becoming a national park, an act that invalidated his mining and business interests. (Sharlot Hall Museum.)

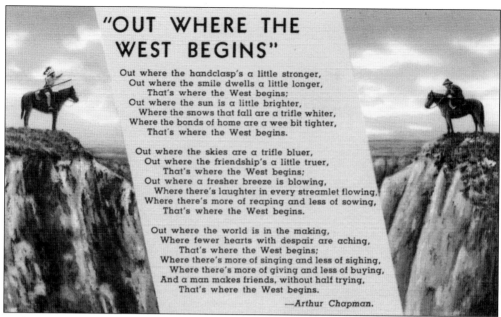

"OUT WHERE THE WEST BEGINS"

Out where the handclasp's a little stronger,
Out where the smile dwells a little longer,
 That's where the West begins;
Out where the sun is a little brighter,
 Where the snows that fall are a trifle whiter,
Where the bonds of home are a wee bit tighter,
 That's where the West begins.

Out where the skies are a trifle bluer,
 Out where the friendship's a little truer,
 That's where the West begins;
Out where a fresher breeze is blowing,
 Where there's laughter in every streamlet flowing,
Where there's more of reaping and less of sowing,
 That's where the West begins.

Out where the world is in the making,
 Where fewer hearts with despair are aching,
 That's where the West begins;
Where there's more of singing and less of sighing,
 Where there's more of giving and less of buying,
And a man makes friends, without half trying,
 That's where the West begins.

 —*Arthur Chapman.*

Arthur Chapman (1873–1935) was an American poet and newspaper columnist. Of his famous 1911 poem "Out Where the West Begins," he wrote, "Today [it] is perhaps the best-known bit of verse in America. It has crossed both the Atlantic and Pacific, while throughout this country it may be found pinned on walls and pasted in scrapbooks innumerable." This linen postcard is from around 1930. (C.T. Art–Colortone postcard.)

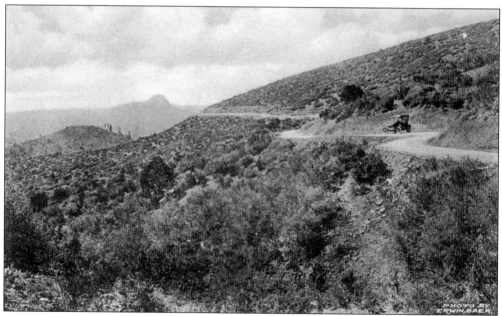

An early-day machine travels the State Highway (Highway 89) near Prescott around 1910, with Thumb Butte in the background. (Erwin Baer photograph, Acker's Bookstore Albertype postcard, c. 1916.)

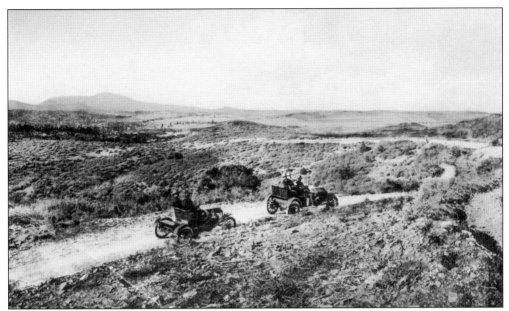

Out for an excursion, the drivers of two early automobiles travel the State Highway near Prescott. The advent of the automobile allowed those who could afford them and were up to the adventure the opportunity to become leisure travelers and to go much longer distances on a Sunday outing than when travel was limited to buggy or horseback. (Brisley Drug Store Albertype postcard, c. 1910.)

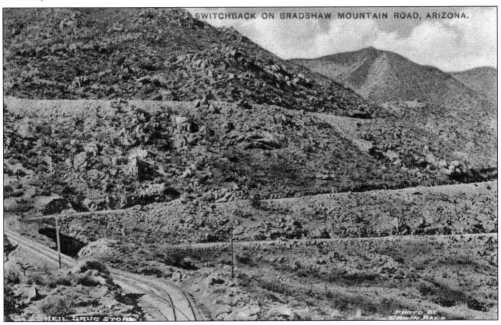

These are the switchbacks on the Bradshaw Mountain Road. Part of the message on the reverse says "Some of the country looks like this and some worse." The *Arizona Good Roads Association Tour Book*, published in 1913, states that there was "a larger mileage of good roads in Yavapai County than in any other county in Arizona." (Erwin Baer photograph, Albertype postcard postmarked June 30, 1914.)

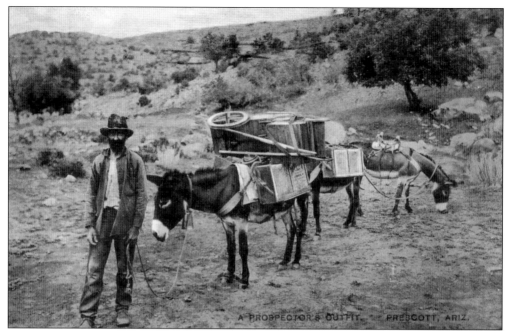

Mining was the reason for the original settlement of Yavapai County. In the mid- to late 19th century, hard work and primitive living conditions still paid off for a few individual prospectors. Labeled "A Prospector's Outfit, Prescott, Ariz.," this image shows a man representative of many of the "strike-it-rich someday" prospectors who combed the hills and vales of Prescott searching for gold well into the 20th century. (Brisley Drug Co. Albertype postcard, c. 1910.)

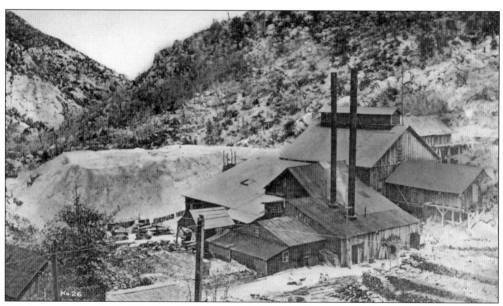

The largest mine in the Bradshaw Mountains of Yavapai County was the Crowned King Mine. The early town of Crown King sprang up on the road between the mine and the mill. The surrounding forests were stripped to feed the boilers that drove the Bradshaw Basin Mill. (Brisley Drug Co. Albertype postcard, c. 1910.)

Cattle ranching was one of the mainstays of the economy in the early days of Yavapai County and is still a factor today. Many longtime ranching families in Yavapai County still run thousands of head of cattle annually. This is the spring roundup at Pitts Ranch in Ash Fork about 1907. (International Stereograph Company.)

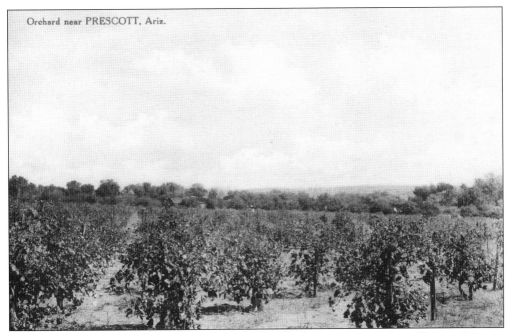

In addition to mining and ranching, farming has played a significant role in Yavapai County, particularly in Chino Valley, Dewey, the Verde Valley, and Sedona. Sedona was famous for decades for fruit, which was shipped all over the world. This is Bianconi's Orchard outside Prescott about 1920. (Brisley Drug Co. Albertype postcard.)

Even into the 1940s, many of the major roads around Yavapai County were unpaved. This is White Spar Road (Highway 89) heading south from Prescott. The message on the reverse says "This is the road, but it doesn't show the grade. We had more than 25 miles each way of this." (RPPC by Frasher, 1947.)

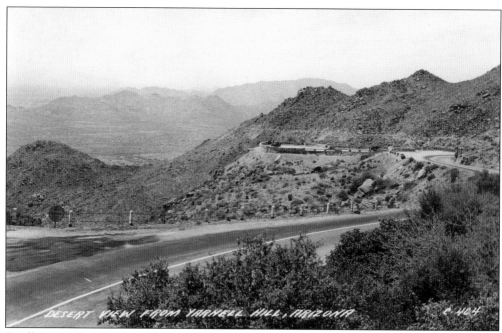

Small towns sprang up along Highway 89 between Prescott and Wickenburg, including Skull Valley, Wilhoit, Kirkland, Peeples Valley, Yarnell, and Congress. This is the lookout at the summit of Yarnell Hill, a place to stop and catch one's breath before or after the terrors of driving Yarnell Hill when it was two very narrow lanes up and down. (RPPC by L.L. Cook Co., postmarked 1946.)

16

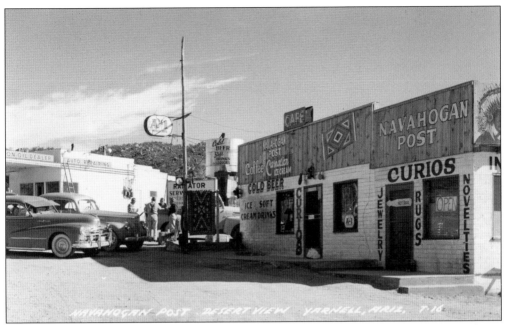

Navahogan was a popular stop with a café and curio shop at Desert View in Yarnell on Highway 89. Notice the A-1 Beer sign. The Union Oil Station next door was one of the few gas stations between Prescott and Wickenburg. The water tank has been decked out with advertisements for "cold beer," "soft drinks," and "liquors." (RPPC by L.L. Cook Co., 1940s–1950s.)

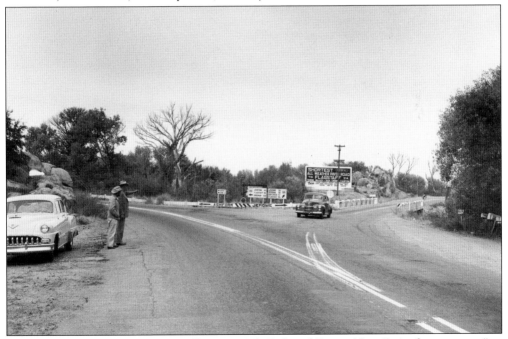

Leaving Prescott to go to Chino Valley or to Ash Fork and Route 66, or "over the mountain" to Jerome and the Verde Valley required heading out of town through Granite Dells to the junction of Highways 89 and 89A and taking one route or the other. The intersection no longer exists. (Arizona Highway Department photograph, 1950s.)

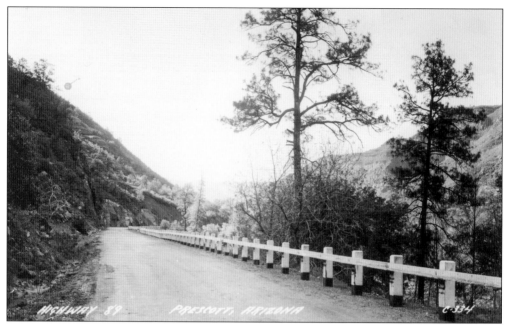

Highway 89A over Mingus Mountain from Prescott to Jerome was constructed around 1920. Although it is not the fastest route, it is certainly the most scenic and tops out at an elevation of 7,025 feet. Today, it is a popular road for sports car and motorcycle enthusiasts. A portion of the road is designated as an Arizona scenic highway. (RPPC by L.L. Cook Co., 1930s–1940s.)

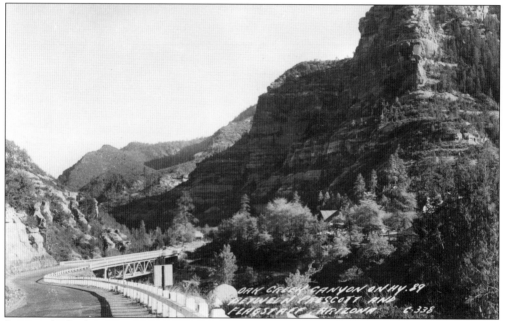

Spectacular highway scenery can be found on Highway 89A (formerly Highway 79) from Sedona through Oak Creek Canyon and on to Flagstaff. According to the Arizona Good Roads Association, "the highway descends to the canyon floor where it twists through broad red-walled gorges and miles of green pine, maple, sycamore, cedar, oak, aspen and fern." (RPPC by L.L. Cook Co., 1930s–1940s.)

Two

CENTRAL YAVAPAI COUNTY

On May 30, 1864, the name Prescott was chosen for the fledgling territorial capital. As Sharlot M. Hall wrote in *Out West* in 1902, "Prescott was born in a gold pan and cradled in the first rude rockers with which the shining golden grains were sifted out of what are now its streets and thoroughfares." Today, Prescott, "Everybody's Hometown," is a major tourist destination. With the Courthouse Plaza as the center of a historic downtown, more than 800 buildings listed in the National Register of Historic Places, museums, regional recreation and events, three colleges, and a four-season climate, Prescott is the ideal place to live or visit.

Once known as Lonesome Valley, Prescott Valley has been the scene of volcanic eruptions, wooly mammoths, pronghorn antelope, and the wanderings of prehistoric people and of miners in search of precious metals. Along with the miners came the ranchers. The valley, with its lush grasses, became the home of herds of cattle. Among the early ranchers were the Fains, who were instrumental in the development of the town. Incorporated in 1978, Prescott Valley today is an innovative and energetic town. Business, industry, and education have come together to build a progressive community vibrant with amenities that continue to attract those looking for their place "to live in the sun."

Chino Valley is situated on a picturesque grassy plain at nearly 5,000 feet in elevation and surrounded by mountains. It owes its founding primarily to its proximity to early mining endeavors near Prescott and its continued existence to its agricultural roots. In 1863, Arizona territorial governor John Goodwin camped at the site of Camp Clark in Chino Valley. Word of the area's potential spread, enticing cattlemen and farmers who utilized the water from the vast aquifer underlying the valley. Because of the region's agriculture, it remained relatively rural in nature until the 1970s. Chino Valley residents incorporated in 1970. With town government came the political wrangling that typifies the growing pains of a new municipality. As Arizona's centennial approaches, the community has moderated, the population continues to increase, and the commercial district has evolved.

Seen here is Prescott's landmark, Thumb Butte, in a view from West Prescott. A man drives a two-hitch team and wagon along what is probably Murphy Drive around 1900. Thumb Butte remains as an icon visible from most of Prescott and much of the west side of Yavapai County.

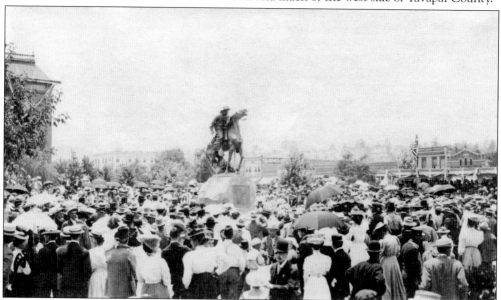

The dedication of the Roughrider Memorial on the Courthouse Plaza on July 4, 1907, brought folks from all around the county to the celebration. The statue, by Solon Borglum, now anchors the front of the newer 1918 courthouse and commemorates those Yavapai County men who fought in the Spanish-American War. (RPPC by Armitage.)

There are no cars in this c. 1905 photograph taken from the Courthouse Plaza looking at the 100 block of West Gurley Street. The Roughrider Memorial stands in the center, with the Mineral Fountain in the foreground. The two-story buildings are the Bashford-Burmister Store on the left and the Union Block on the right. All of the buildings in this photograph are still standing.

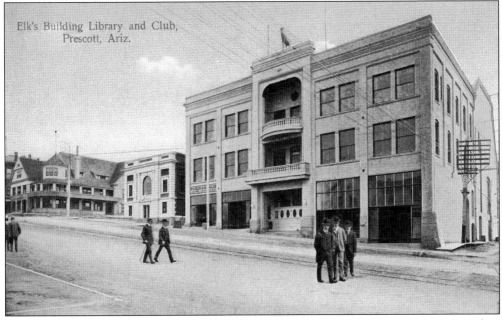

The Elks Opera House was completed in February 1905 and provided Prescott and the surrounding area with a first-class opera house. Built by the Benevolent and Protective Order of Elks Lodge 330 as a part of its new lodge, the Elks Opera House was restored to its 1905 grandeur in 2010. It is listed in the National Register of Historic Places. (Publisher M. Rieder, c. 1910.)

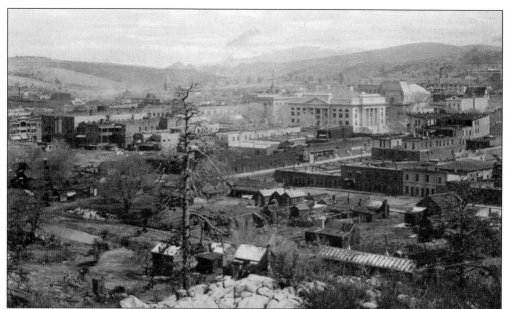

After a devastating downtown fire in July 1900, Prescott rebuilt. Statehood began a long period of industrial and population growth for the town. By 1916, Prescott was a well-established community and the business and financial center of Yavapai County. Downtown Prescott around 1920 reflects the prosperity of the area. (Acker's Bookstore Albertype postcard.)

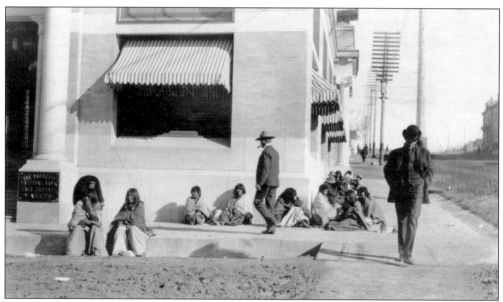

The members of the small Yavapai Indian tribe lived in and around Prescott and were frequent visitors to town. Here, a group of Indians is sitting on the sidewalk and the curbs at the intersection of Cortez and Gurley Streets in front of the Prescott National Bank Building. Since the streets are not paved, this image probably dates to about 1910. (Sharlot Hall Museum.)

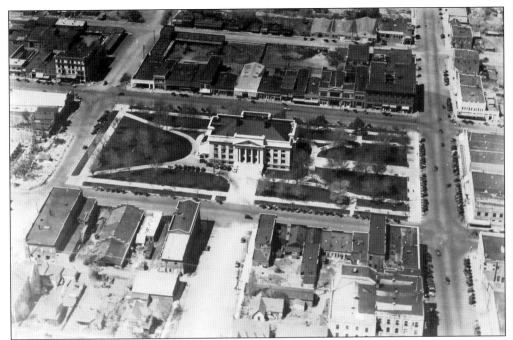

This late-1920s aerial view of downtown Prescott facing west shows the 1918 courthouse in the middle of Courthouse Plaza. Gurley Street is on the right and Goodwin Street is on the left. Union Street is in the foreground. South Montezuma Street is on the west side of the plaza. Many of these buildings are still there today.

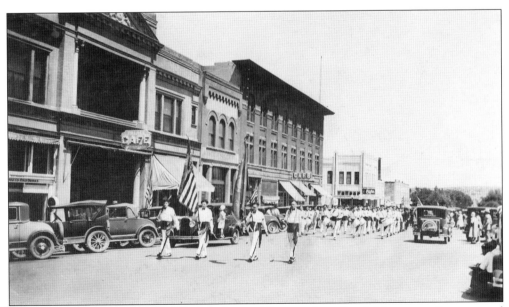

An American Legion group marches in a Memorial Day parade on South Montezuma Street around 1930. The Brinkmeyer Hotel and Bakery are in the right background, and the Wilson Block is on the northwest corner of Gurley and Montezuma Streets. The Hotel St. Michael is next, then the Levy Building and the famous Palace Saloon. The Palace is still in business today.

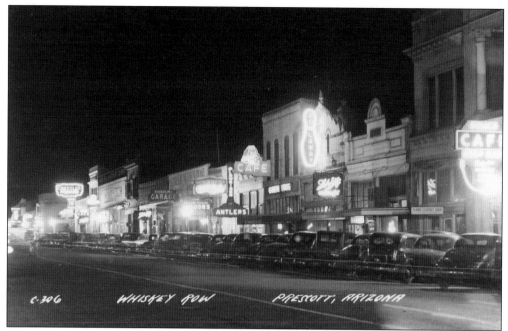

This nighttime photograph of Prescott's famous "Whiskey Row" during World War II shows that things are "a-hoppin," with bars and restaurants, a bowling alley (two lanes), and hotels all along the row. The neon signs really light up the night. Most of these buildings are still standing, and many are listed in the National Register of Historic Places. (L.L. Cook Co. RPPC.)

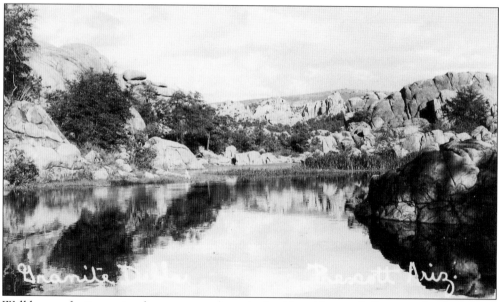

Well known for its spectacular scenery and granite boulders, Granite Dells in northeast Prescott is a favorite destination for boaters, hikers, and rock climbers. The Granite Dells are the backdrop for Watson and Willow Lakes. In earlier years, Sherman Payne's family ran the Granite Dells pool and boating lake, shown here about 1930, on the east side of Highway 89 in "The Dells." (RPPC mailed April 3, 1940.)

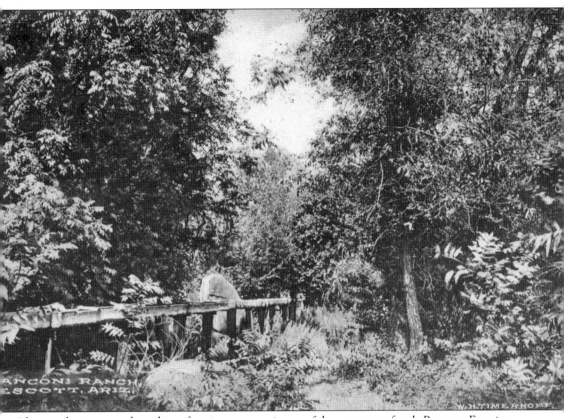

Along with mining and ranching, farming was a mainstay of the economy of early Prescott. Farming often required irrigation. This image shows the wooden pipeline from Granite Creek to Bianconi's Ranch on Highway 89 about 1910. (Albertype published by W.H. Timerhoff, postmarked 1913.)

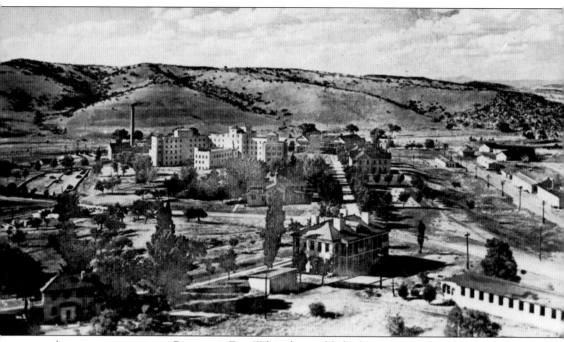

An important entity in Prescott is Fort Whipple, established in 1864. By the early 1900s, the fort had been transformed into a veterans' medical facility, as it is today. This 1950s view looking north-northwest shows the Veterans Administration Medical Center, with the hospital in the center. The property, which includes 39 historic buildings and a national cemetery, is listed in the National Register of Historic Places. (Northrup RPPC.)

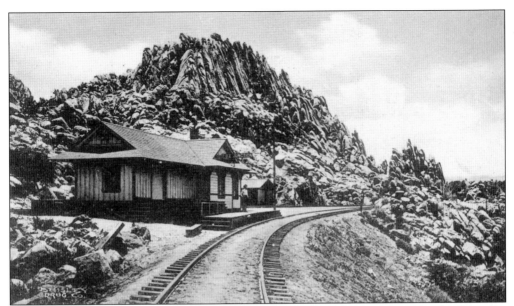

In 1886, the short-lived Prescott & Arizona Central Railroad (soon replaced by the Santa Fe, Prescott & Phoenix) arrived in Prescott from the Atlantic & Pacific Railroad to the north. Branch lines, such as the Prescott & Eastern (P&E), provided transportation for people, livestock, ore, and merchandise throughout the county. This is the P&E Junction at Point of Rocks in Granite Dells about 1900. (Brisley Drug Co. postcard.)

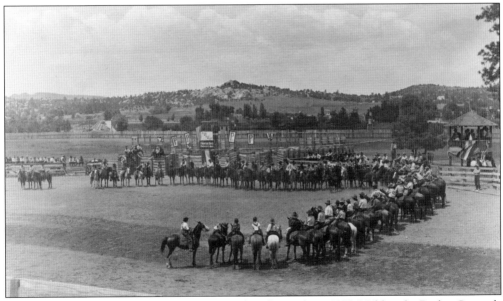

Prescott is the home of the World's Oldest Rodeo, dating from 1888. Held at the Rodeo Grounds in Prescott just north of downtown annually during the week of July 4, the rodeo today draws participants and visitors from around the world. This image of a group of horsemen at Prescott Frontier Days probably dates from the 1930s.

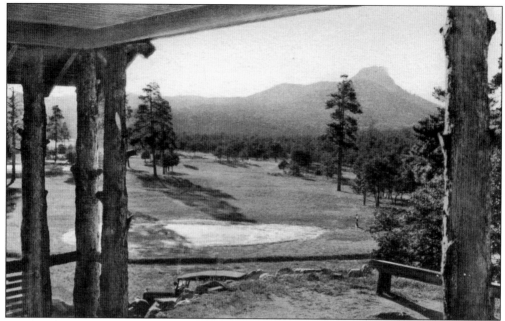

By the 1920s, two new local commodities were beginning to come to the forefront: the mild, four-season climate and the beautiful scenery. Tourism was soon a major factor in the economy and growth of Yavapai County, with the railroad and the automobile contributing to the popularity of touring the great Southwest. Recreational opportunities included golf, as seen here at the Old Hassayampa Country Club in the 1920s. (Robinson's News Stand Albertype.)

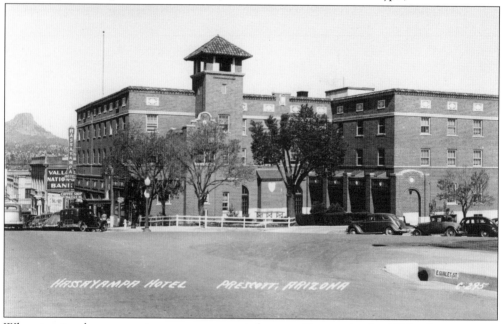

When tourism became an important economic boon to Prescott in the 1920s, there were no hotels designed to cater to the automobile traveler. Through the sale of stock, funds were raised to build the Hassayampa Inn, which opened to great fanfare in 1927. It is still one of the finest hotels in Prescott. (RPPC by L.L. Cook Co. c. 1940.)

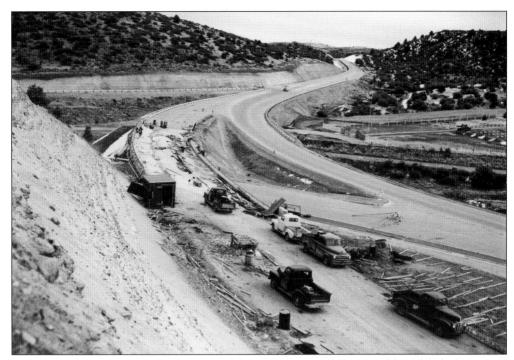

As automobile travel expanded after World War II, State Highway 69 (the Old Black Canyon Highway) was redesigned and improved to provide a route to Prescott that did not involve the dreaded Yarnell Hill. This is the intersection of Highways 69 and 89 under construction about 1959. Highway 69 changed the entrance to Prescott from White Spar Road to East Gurley Street. (Arizona Highway Department.)

Once an active volcano, Glassford Hill, at an elevation of 6,177 feet, looms as the landmark for Prescott Valley. It is named for Col. William A. Glassford, once stationed in Prescott at nearby Fort Whipple. Colonel Glassford established a system of 27 heliograph stations, including one atop Glassford Hill, in the late 19th century. (Jean Cross Collection.)

Lonesome Valley was undeveloped, with lush grasses, wide open spaces, and grazing cattle. In the mid-20th century, with the construction of Interstate 17 connecting Phoenix and Flagstaff and the opening of Highway 69, Lonesome Valley became an attractive site for development, and efforts to market the area to people living in the East resulted in many colorful promotional land opportunities. Today, it is completely developed. (Fain Family Collection.)

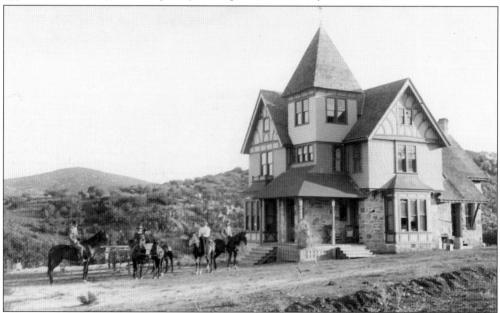

Thomas Gibson Barlow-Massicks arrived in the area of what is now Fain Park in the early 1890s. Shortly thereafter, he built the "Castle," now known as the Barlow-Massicks House, which still stands and is a historic feature of Fain Park. Barlow-Massicks had a gold-mining operation in Lynx Creek Canyon and established the mining camp of Massicks just east of the Castle. (Town of Prescott Valley.)

Seen here is an early, unidentified miner working in Prescott Valley. (Town of Prescott Valley.)

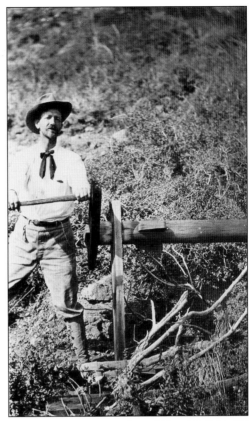

This image shows a ranching scene in Lonesome Valley, perhaps the Fain family cowboys. (Town of Prescott Valley.)

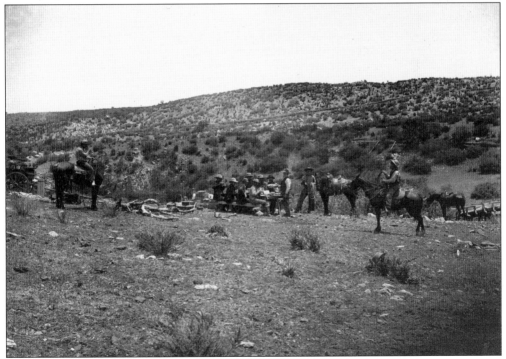

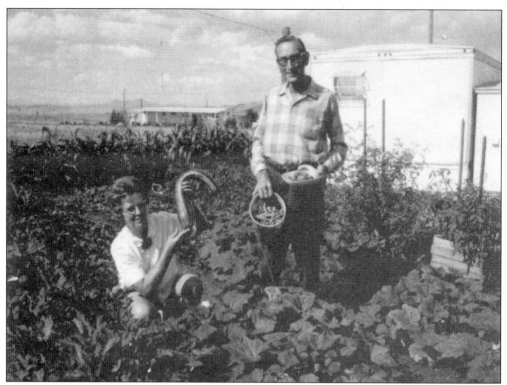

Once development took off, new residents in the town of Prescott Valley found the area perfect for gardening; today, what was once open grassland is a green oasis with many lush and beautiful gardens. (Jean Cross Collection.)

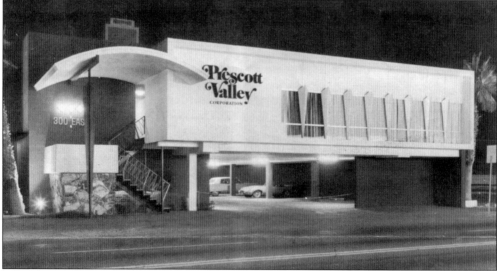

In the mid-1960s, Prescott Valley Inc. became the leader in the development of Prescott Valley. Sales were brisk, and new property owners were invited to view their land purchases. They were accommodated in the newly constructed Prescott Valley Motel. Soon, an activity center, gas station, and a strip mall were built adjacent to the motel. Prescott Valley was on its way. (Jean Cross Collection.)

Fain Park, once the site of placer and hydraulic mining, features the Chapel of the Valley, the Castle, Fitzmaurice Ruins, and Fain Lake. It is a delightful and scenic spot for fishing, hiking, and picnicking. The chapel was built by the Fain family in tribute to Johnnie Lee Fain. The Fain family donated the 100-acre site to the Town of Prescott Valley. (Town of Prescott Valley.)

At an elevation of 5,000 feet, snow is not too common in Prescott Valley. However, it does occasionally provide town residents with a winter wonderland scene. Here, Fain Park wears a winter coat of snow and ice in 2009. (Town of Prescott Valley.)

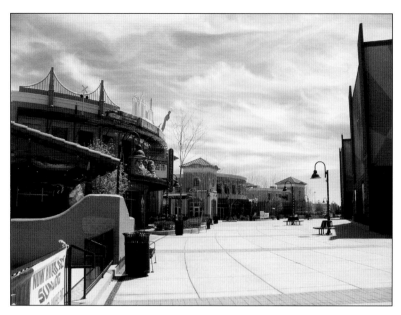

Today, Prescott Valley is an up-and-coming community with a vibrant commercial center with restaurants, city offices, a theater, and small shops. In contrast to historic Prescott, Prescott Valley strives to be a modern town with cutting-edge architecture and planning. (Town of Prescott Valley.)

Between 1990 and 2000, Prescott Valley was the seventh fastest growing town in Arizona. In the 1990s, the Town of Prescott Valley began development of a new and exciting downtown with an entertainment district that includes a movie theater, restaurants, and other entertainment venues. (Town of Prescott Valley.)

Designed by Jim Richard and Kelly Bauer, Prescott Valley's award-winning library reflects the town's trend to very modern, energy-efficient, multipurpose government buildings that use high-tech materials along with more traditional materials in new ways. (Town of Prescott Valley.)

As can be seen from this aerial view, looking mostly north, Prescott Valley has experienced phenomenal growth in its almost 50 years of existence. The entertainment district and a multiuse professional sports arena (Tim's Toyota Center, center, right) are shown here, flanked by a portion of the residential area. (Town of Prescott Valley.)

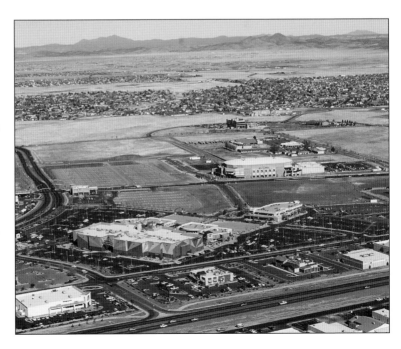

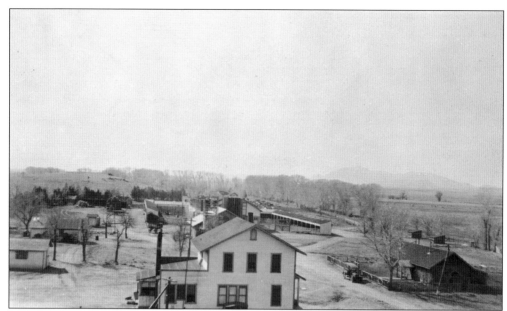

Del Rio Springs, with its abundant artesian springs and location near the headwaters of the Verde River, saw substantial activity during the brief tenure of the territorial government in 1863–1864 as well as throughout the area's history. Casa del Rio, the adobe building that is believed to have been at the springs before the establishment of Arizona's first temporary territorial capital there, is visible at lower right. (Sharlot Hall Museum.)

Chino's first stagecoach station was constructed and operated by early settlers George and Mary Banghart, who established it just north of Del Rio Springs around 1866. It served as an inn and social center. It was rebuilt after being destroyed by fire in 1878. Among its endeavors, the family ran a gristmill and dairy. (Sharlot Hall Museum.)

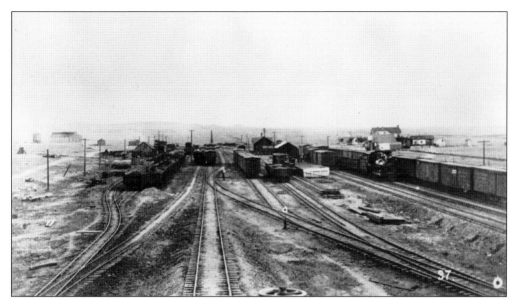

The second settlement in the valley was Jerome Junction, later called Copper, which was the terminus of the narrow gauge railroad from Jerome. The post office was established in 1895. The town evaporated by 1925, its structures relocated or reused for building material. Foundations at the site near where Perkinsville Road crosses the old railroad bed are all that remain to attest to its past. (Sharlot Hall Museum.)

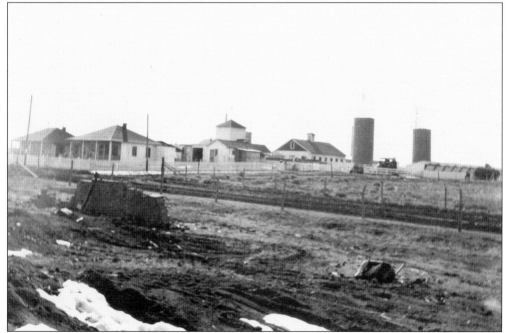

Hassayampa Alfalfa Farms, an early agricultural enterprise, dammed Granite Creek in 1914, creating the Watson Lake irrigation reservoir. This allowed farming in Chino Valley's previously dry southern section. Its headquarters were in the building to the left. The farm was recently deeded to local schools by its last owners, the Coopers. The venture was the forerunner of the Chino Valley Irrigation District. (Sharlot Hall Museum.)

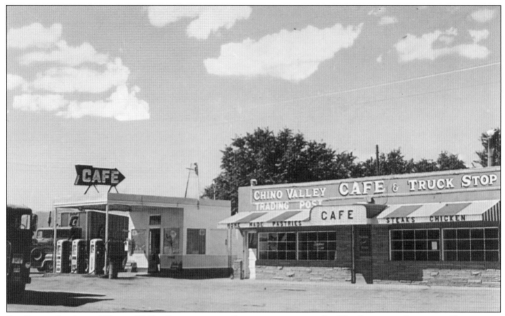

In the early days, Chino Valley's commercial aspect consisted of little more than small services for locals in addition to a few businesses that also catered to traffic traveling through on Highway 89. With little exception, the business area remains clustered along that highway, now a heavily traveled thoroughfare. Increasing volume and a variety of businesses allow residents to do more of their shopping locally. (Dexter Press Postcard, photograph by Dean Riggins.)

In 1916, Anton Johnson took title to his 160-acre Chino homestead after improving the property utilizing recycled structures from Jerome Junction. A portion of that farm is now Granite Creek Vineyards, created by the Hoult family, who restored the buildings and listed the property in the National Register of Historic Places. Producers of organic wines on their oasis-like property, the Hoults offer wine tastings, live music, and special events. (Courtesy Hoult family.)

Three

NORTHERN YAVAPAI COUNTY

Ash Fork is not a town that progress would leave in the dust. Sitting in Yavapai County's northern tier, Ash Fork was 30 years old when Arizona became a state in 1912. At its pinnacle, Ash Fork, named for a stand of ash trees, was a major railroad hub, boasted the exquisite Fred Harvey House Escalante Hotel, and was a destination point along legendary Route 66, the "Mother Road" that stretched from Chicago to California. Over time, two fires, one in 1893 and another in the 1970s, destroyed many of the town's buildings. The railroad line moved further north, and Interstate 40 replaced Route 66 as a main east-west artery. Yet, like the phoenix bird, Ash Fork has always risen from the ashes. Today, it continues as the "Flagstone Capital of the USA," remains prime ranching country, and diligently preserves its historic roots.

Ash Fork's showcase is the Ash Fork Route 66 Museum, which gives a glimpse of the past. Visitors will see a replica of an early-day schoolroom, a vintage telephone switchboard, the reproduction of a historic saloon, a scale model of the fabled Hotel Escalante, and a cell from the Yuma Territorial Prison.

Seligman's first name was Prescott Junction because it also connected with a railroad feeder line, but in 1886, the town came into its own and took on the name of Jesse Seligman, who helped raise the money for the railroad project that brought train service to the West. Just as for Ash Fork, Route 66 buoyed Seligman into even more of a boomtown, as business flourished for the town's motels, cafés, and gas stations along the Mother Road. The future looked gloomy for Seligman, too, when the railroad pulled up stakes and Interstate 40 pushed its way across the country, bypassing the small community. In the beginning, Route 66 helped Seligman prosper. In the end, Seligman helped keep Route 66 alive. Today, the town is a member of the Historic Route 66 Association of Arizona and attracts visitors with many fun events that take place along the legendary highway of days gone by.

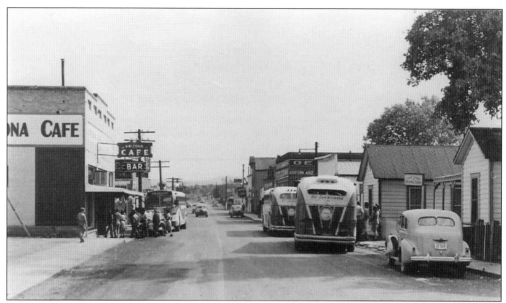

Ash Fork's Main Street of the 1930s, eventually renamed for T.C. Lewis, bustled with activity after Route 66 opened up for automobile traffic in 1926, and Americans took to the highway in increasing numbers. Tourists flocked to the area as they traveled along, stopping for meals, gas, and lodging. (Lewis Hume.)

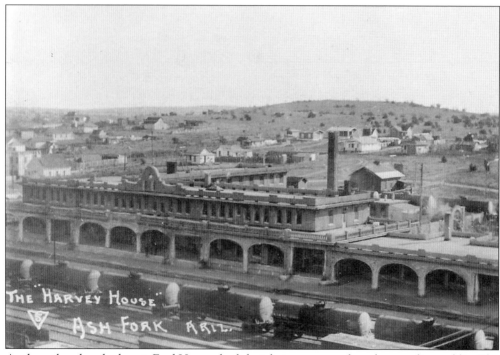

As the railroad pushed west, Fred Harvey built hotels to accommodate the traveling public. The fabulous Escalante Hotel in Ash Fork was the crown jewel along the Atchison, Topeka & Santa Fe line. The $115,000 hotel opened March 1, 1907, and was in operation for almost 50 years. A scale replica reminds visitors to the Ash Fork Route 66 Museum of its splendor. (Lewis Hume.)

In 1915, Lewis Avenue was still dirt, but modernization of the town's amenities had already begun to take place with the famous Escalante Hotel, straight west in this photograph, as Ash Fork's centerpiece. Hotel mogul Fred Harvey built the Escalante in 1907. (Lewis Hume.)

Thomas Cooper Lewis, Ash Fork's first businessman, originally from Illinois, came to Prescott in 1872 and then headed north to what would become Ash Fork. He knew that people had to eat, historians say, so his first business was a store, located on the corner of Third Street and Railroad Avenue. J.W. Stone built the store for Lewis before 1900, and it still stands today. (Lewis Hume.)

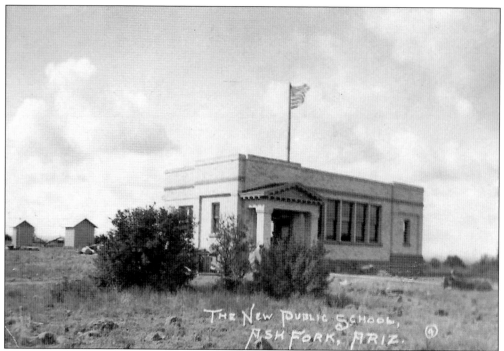

A new school was built in 1915 to replace the town's one-room schoolhouse. This and earlier schools of 1893 and 1907 no longer exist, but a replica of a vintage school stands in the Ash Fork Route 66 Museum. There, visitors can see a figure of a teacher, old desks, and other relics of days gone by. (Lewis Hume.)

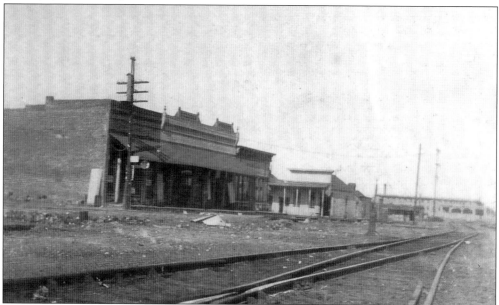

Railroad Avenue, dedicated in 1892, had board sidewalks leading to the railroad tracks and several small businesses, including a postal and telegraph office, a store, and a saloon. The railroad was the backbone of Ash Fork, yet freight loads were a hard pull up the hill going east, so the main line was moved to a better location north of town in 1960. (Lewis Hume.)

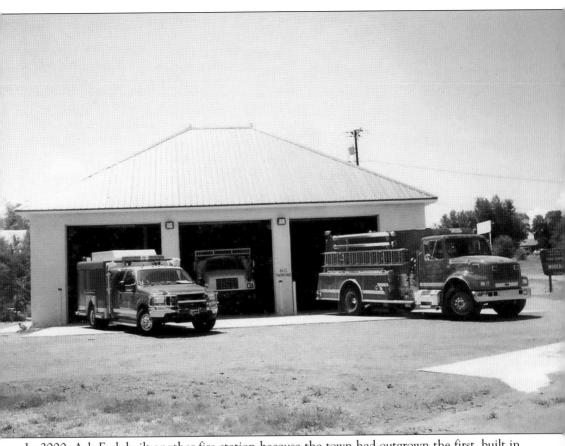

In 2000, Ash Fork built another fire station because the town had outgrown the first, built in 1941. In 1971, fire chief Lewis D. Hume bought a new truck to replace the old 1946 model, and as he drove it into town, people lined the streets, cheering its arrival. The 1946 truck is now parked inside the Ash Fork Route 66 Museum. (Lewis Hume.)

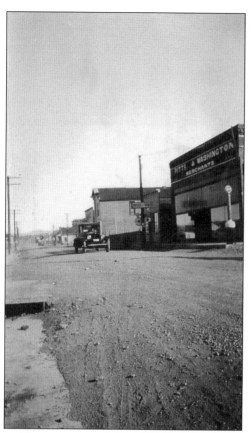

A vintage auto trundles along Lewis Avenue in Ash Fork in the 1920s, when the town was mainly a railroad town and in the heart of ranching country. By 1926, the quiet little community became a stopping place for vacationers who drove Route 66 to visit national parks and other scenic destinations on its path. (Lewis Hume.)

People lined the brick walkway in front of the Escalante Hotel and depot to wave at passengers riding in the first passenger diesel to reach Ash Fork in the 1940s. (Lewis Hume.)

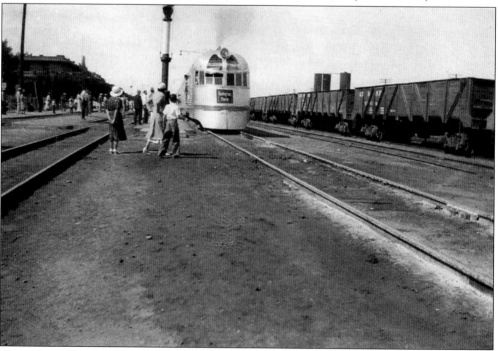

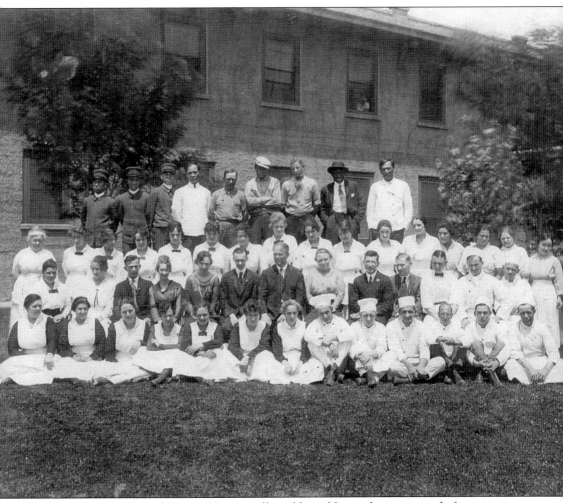

The Escalante Hotel's Fred Harvey House staff would quickly get the rooms ready for incoming railroad crews. As legend has it, a prominent New Yorker traveled out west and upon his return home, he wrote to the hotel's office in Kansas City, asking, "Can I get at my club here beefsteaks just like the one I had at your eating house in Ash Fork?" (Lewis Hume.)

The Coconino flagstone in the hills around Ash Fork is one of the finest stones for buildings, walks, patios, and fireplaces. Ash Fork stone is shipped around the world. Stone workers from an earlier era were known as "rock doodlers." They were a colorful, hardworking, hard-drinking breed that could raise quite a ruckus on payday. The stone industry is Ash Fork's livelihood today. (Drake Stone.)

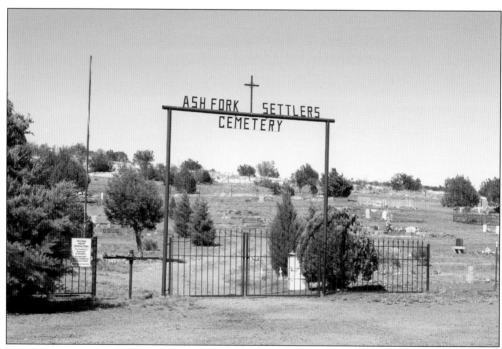

T.C. Lewis acquired land from the Santa Fe Railway, which he in turn dedicated to Yavapai County in 1911 for a cemetery. Town folk volunteer to maintain Settlers Cemetery. (Lewis Hume.)

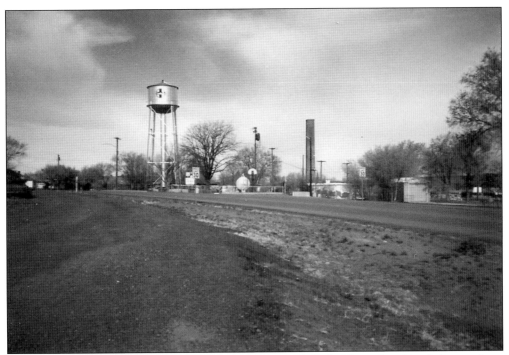

The Santa Fe water tower is a prominent landmark in Ash Fork. The railroad hauled water from Del Rio Springs and pumped it into the tower for the owner of the Ash Fork Water Company. (Lewis Hume.)

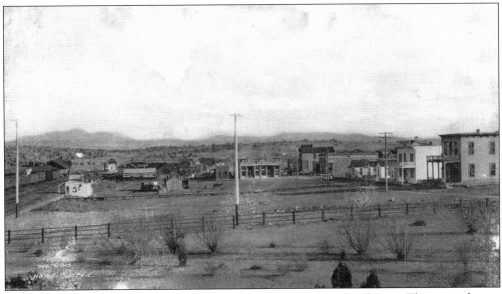

In this 1890s view of Ash Fork, the town was in its prime as a railroad town. The original stage depot and townsite were located near Ash Creek, named for ash trees, where three southerly flowing forks of Ash Creek came together, giving the town its name. (Sharlot Hall Museum.)

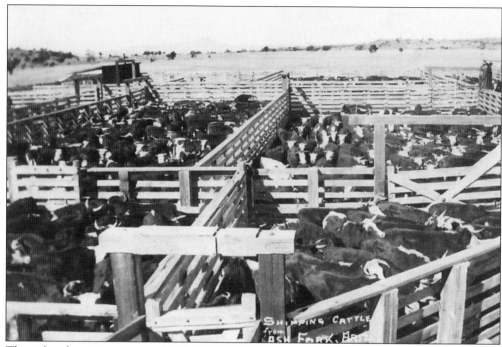

The railroad was important to local ranchers. Ash Fork Livestock Co. and Duff Brown ran cattle ranches on the grass-carpeted ranges, and stockyards were built on the outskirts of town. From there, cattle were shipped off by rail. Today, travelers along Interstate 40 still marvel at the area's sprawling ranch country. (Lewis Hume.)

This flagstone pillar, which no longer stands, helped point the way to Ash Fork at the junction of Route 66 and Highway 89, which headed south to Prescott and Phoenix. Ash Fork is known as the "Flagstone Capital of the USA." The Robert Dunbar family opened its stone yard in Ash Fork in 1945, and today the third generation operates the business. (Lewis Hume.)

Even today, ranches dot the landscape surrounding Ash Fork. In the old days, the Campbells, with their Bar-Z-Bar brand, ran 2,500 head of cattle. At that time, rustlers and thieves were serious problems, and villains the law caught up with were hanged on an ash tree. The Ash Fork Route 66 Museum displays such a "hangin' tree" among its current exhibits. (Lewis Hume.)

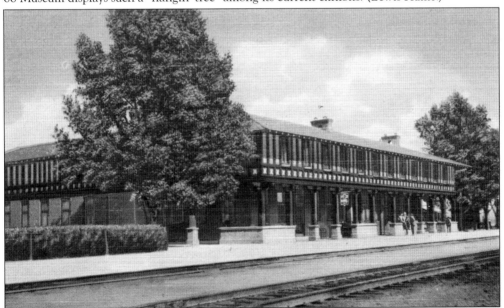

Every train that came through Seligman stopped for maintenance, crew changes, and to allow passengers to eat. Seligman had the Havasu, one of the five Harvey Houses that the company built in Arizona and provided guests with a "wonderful restaurant," newsstand, and lodging. With the advent of dining cars on trains, the Havasu closed its doors in 1954 and was torn down in the late 2000s. (Fred Harvey postcard postmarked April 17, 1954.)

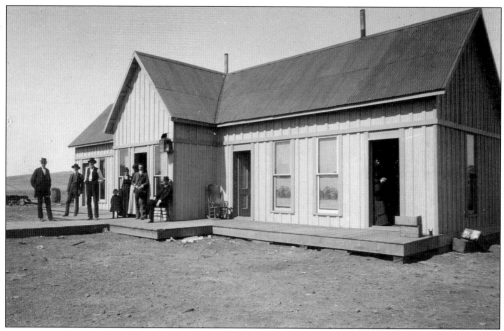

Work to build railroads began in Arizona in the 1880s and presented arduous obstacles for construction crews because of the area's rocky terrain and scarcity of water. Santa Fe put depots at intervals along the line, including Seligman, where a railroad hotel was built in 1887. (Sharlot Hall Museum.)

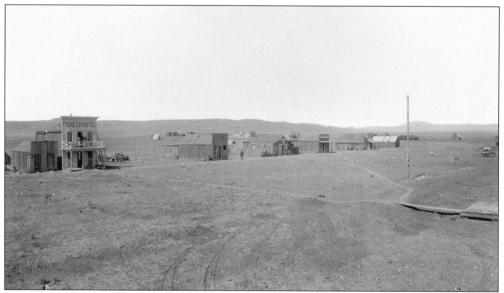

The beginning of Seligman was the junction of the Prescott & Arizona Central Railroad feeder line and the Atlantic & Pacific Railroad. At this time, the fledgling community was known as Prescott Junction and was located a mile southeast, before it was moved to its present location. The town is named for Jesse Seligman, who helped finance railroad lines in the area. (Sharlot Hall Museum.)

Despite progress that forever altered Seligman's destiny, ranching, such as at the Cowden Hereford Ranch shown here in the 1960s, is still one of the largest industries in this area. Both cattle and sheep have been raised in the vast expanse of this part of Yavapai County since the 1880s. Many of the original ranches are still in business today, though they ship their livestock by truck now. (Sharlot Hall Museum.)

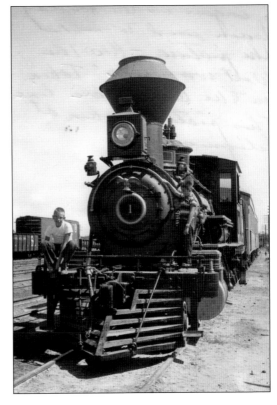

Arizona always has been a popular location for movies, not only because of its history but also because of its majestic scenery. This photograph from a collection of historical Seligman images shows Santa Fe Engine 1, which was used in the fabled 1960s movie *How the West Was Won*. (Sharlot Hall Museum.)

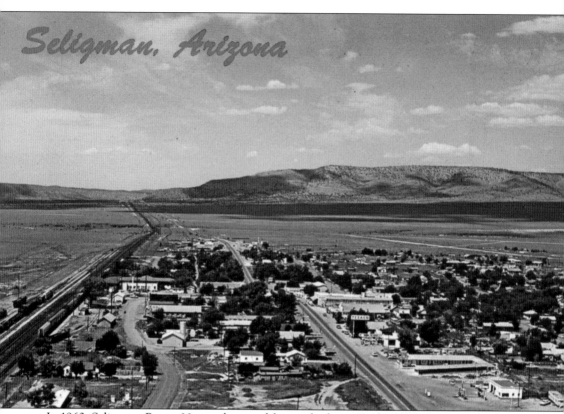

Seligman, Arizona

In 1960s Seligman, Route 66 was a busy and famous highway. In the 1970s, Interstate 40 bypassed it as the major east-west freeway. In 1987, Seligmanites, along with fellow Route 66 lovers in Kingman, founded the Historic Route 66 Association of Arizona. Through their efforts, the State of Arizona dedicated U.S. 66 from Seligman to Kingman as Historic Route 66. Seligman is designated as the "Birthplace of Historic Route 66." (Agfachrome postcard by Petley Studios.)

Four

WESTERN YAVAPAI COUNTY

Bagdad may be off most travelers' paths, but the small town is the site of one of Yavapai County's most significant mining operations. Bagdad began in the late 1800s as a small mining camp of tents on the banks of Copper Creek. Until 1945, mining was conducted underground, but that year a major milestone was the conversion to an ongoing open-pit operation. In 2009, Bagdad's operation produced 225 million pounds of copper and six million pounds of molybdenum, having a multimillion-dollar impact on the economies of both Yavapai County and Arizona. Free mine tours are available.

The town of Congress sits about halfway between Wickenburg and Prescott on Highway 89. This entire section of Arizona became inhabited because of gold mining. A bonanza gold strike on Rich Hill started it all in the 1860s. The claim that would later become the Congress Mine was staked around 1883 by Dennis May. In 1889, May sold his mine to James "Diamond Jim" Reynolds, an eastern businessman who had money and resources to increase mining development. It was he who named it "The Congress." Soon, the Congress Mine became one of the busiest gold mines in the Arizona Territory, churning out millions of dollars. Eventually, the Congress Mine played out and closed in 1910. For much of the latter 20th century, Congress remained fairly small. However, like much of Arizona, Congress has grown rapidly in recent years.

As settlers came to the new territorial capital of Prescott in 1864, they looked beyond the surrounding mountains for good, arable land for farming and ranching, primarily of angora goats and cattle. Soon, in a beautiful and fertile valley about 18 miles southwest of Prescott, a new settlement emerged with the unusual name of Skull Valley. In the 1870s, Skull Valley was a major stage and freight stop. The Santa Fe, Prescott & Phoenix Railway reached Skull Valley in 1894. Burlington Northern Santa Fe Railway trains still go through the valley, but they no longer stop. Today, ranching and farming remain the primary industries of beautiful Skull Valley.

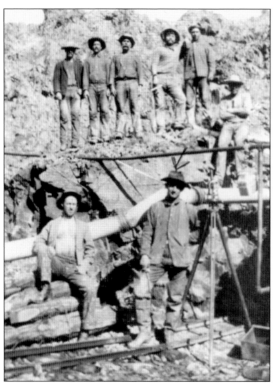

Mining is hard work, physically and mentally. These men at the Bagdad Mine about 1910 are posing at the entrance to the mine. Notice the ore car tracks leading into the mine. The man with the arrow above his head (first row, on the right) is Henry Geisendorfer. (Sharlot Hall Museum.)

This is a view of the Cypress Bagdad Mine about 1959. Over time, ownership of the mine went through multiple hands. The Bagdad Mine became part of the Phelps Dodge portfolio in 1999 with that company's acquisition of Cyprus Amax Minerals Co. and in 2007 joined the Freeport-McMoRan group when it acquired Phelps Dodge. (Sharlot Hall Museum.)

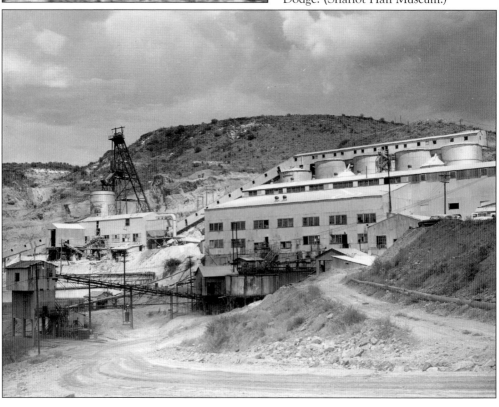

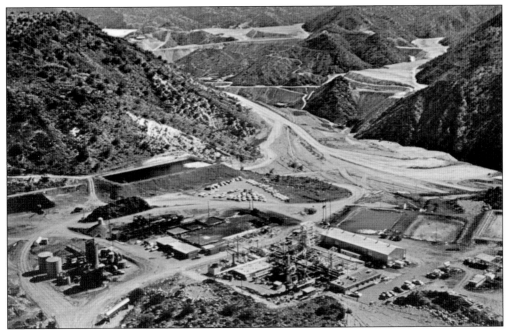

Bagdad is on the cusp of the Mohave and Sonoran Deserts at the end of Arizona Highway 96. The operation covers 21,743 acres, mostly patented claims and fee lands plus 600 acres of unpatented mining claims. This 1960s view of the Bagdad Copper Corporation Mine shows the acid plant, refinery, and leach plant area. (David C. Lincoln, Kingman Photo Service postcard.)

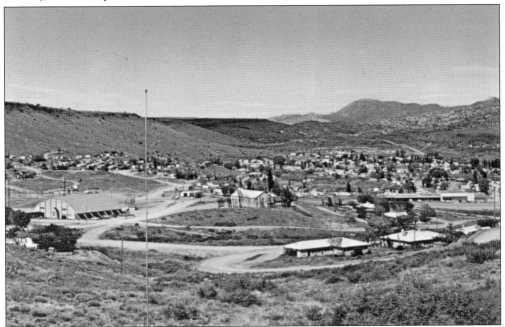

Bagdad's profile changed dramatically in the 1950s when a town was laid out and houses were moved in for mine employees. In 1976 and 1979, the owners of the mine built a shopping center and Spanish-style homes for their workers. The town was recognized by Yavapai County as a master planned community. (David C. Lincoln, Kingman Photo Service postcard.)

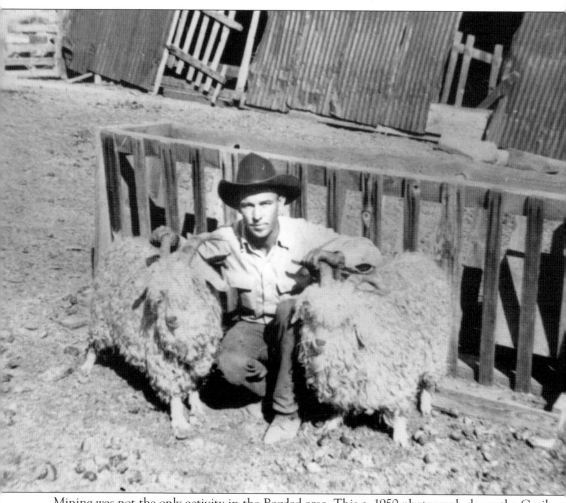

Mining was not the only activity in the Bagdad area. This c. 1950 photograph shows the Cecil Janes Goat Ranch in the Wild Horse Basin near Bagdad and two of the prize angora goats that were raised on the ranch. The man is unidentified. (Sharlot Hall Museum.)

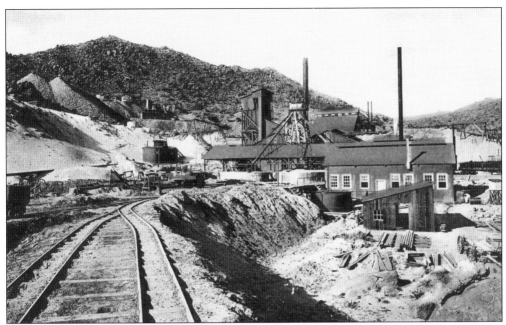

The Congress Gold Mine sprang into existence in 1884. Upon the death of Diamond Jim Reynolds in 1891, it was purchased by a group of investors including Frank Murphy, who had been fighting hard to get the railroad to Congress. Finally, in 1893, Congress Junction, three miles from the mine, became a major stop on the Santa Fe, Prescott & Phoenix line between Prescott and Phoenix. (Parker Anderson Collection.)

Hoping to expand the SFP&P Railway, railroad developer Frank Murphy persuaded President McKinley to make a special trip from Phoenix to the Congress area on May 7, 1901. Here, McKinley (third from left) and his party are photographed in the Blue Tank Mountains. McKinley spent nearly three hours touring the area and the Congress Mine. (J.C. Hummert Stereoview by Underwood & Underwood.)

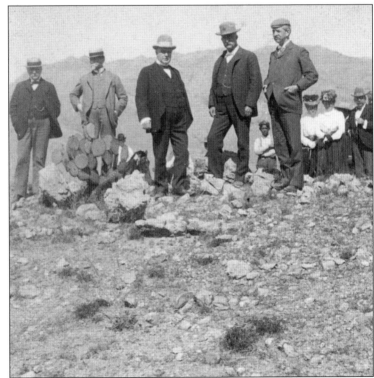

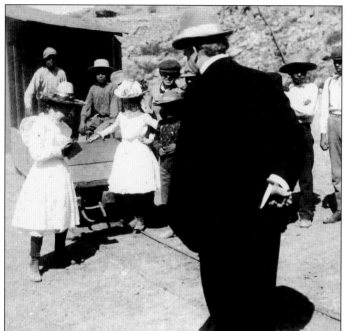

President McKinley entered the electrically illuminated Congress Mine tunnel for a distance of about 1,500 feet and appeared to be moved by a group of underground miners waving American flags. Here, outside the Congress Mine, he is greeted by the local children and is photographed by a miner's young daughter. (J.C. Hummert stereoview by Underwood & Underwood.)

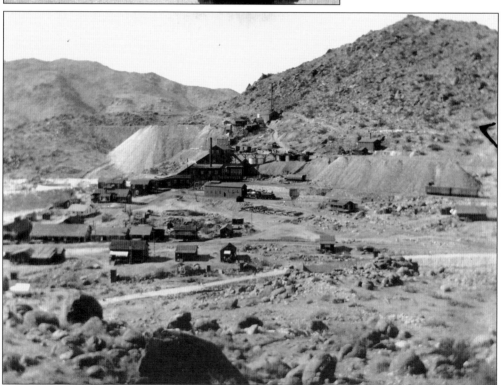

This 1903–1904 overview of the early days of Congress shows the Congress Gold Mine in the background. At its peak, the Congress Mine employed over 400 men. They needed a place to live, so houses and stores started were constructed at the mine site. A post office was added, and this became the original town of Congress. (C.P. Hart photograph.)

These three men are sitting in front of the Congress Gold Mine on barrels that are covered in what appears to be canvas or burlap and wooden lids. They are clearly not dressed for mining but may be office workers or just visitors. Two of these men are Al R. "Billy" Bayless and Beitz Warren. (C.P. Hart photograph.)

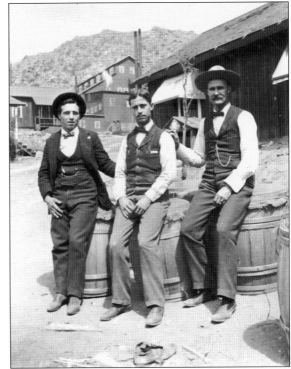

These American Indians, probably Yavapai, wearing their traditional late-19th-century dress, are congregated at the Congress Gold Mine. They seem to be very interested in the contents of one of the wooden crates. (C.P. Hart photograph.)

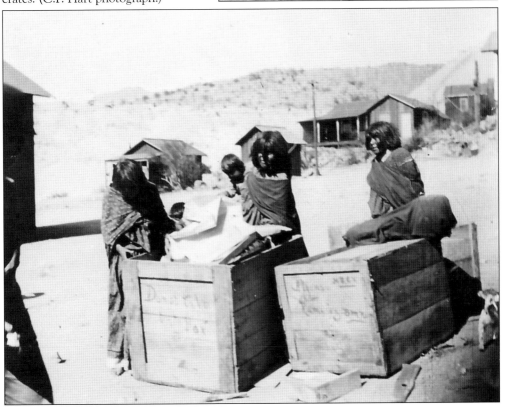

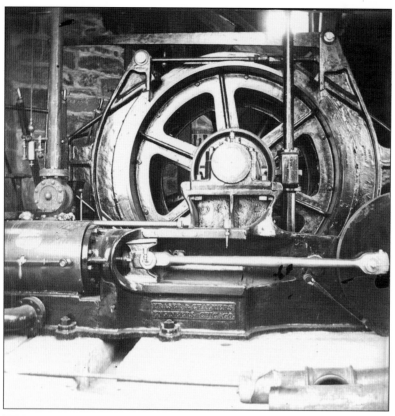

Huge mining equipment was necessary to not only remove the ore from the ground but also to process it. The cost and difficulty of obtaining and installing this equipment led to the failure of many mines. This hoist is at the Congress Gold Mine. (C.P. Hart photograph.)

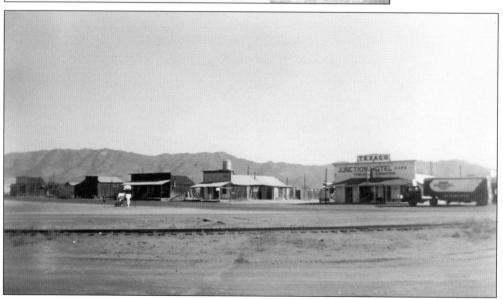

After the mines closed, homes and businesses were built at the junction of the SFP&P and the Congress Consolidated Railroad a few miles south of Congress. Named Congress Junction, it was given a boost in the 1920s when Highway 89 was routed through, making a nice stop for travelers. Eventually, "Junction" was dropped, and today it is simply known as Congress. Seen here are the Junction Hotel and Texaco station in 1942.

There are many versions of the story of how Skull Valley was named. Will C. Barnes, in *Arizona Place Names*, supports a version that the remains of Indians killed in a battle between soldiers and Mohave and Tonto Apache Indians in 1864 were found here and that the place was named Skull Valley by Maj. Edward B. Willis. The facts are still unknown. Seen here is the Gist Ranch in 1920.

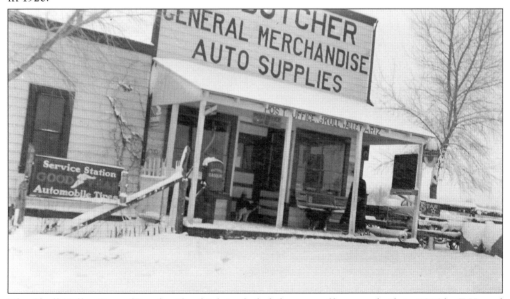

The Skull Valley Store (Dutcher's), which included the post office, was built in 1916 by E.K. and Florence Dutcher. The store had a little of everything, including gasoline and tires, a butcher shop, and clothing. Many of the early customers were mule skinners who hauled ore to the railroad at Skull Valley. Still in business, the store looks much today as it did almost 100 years ago.

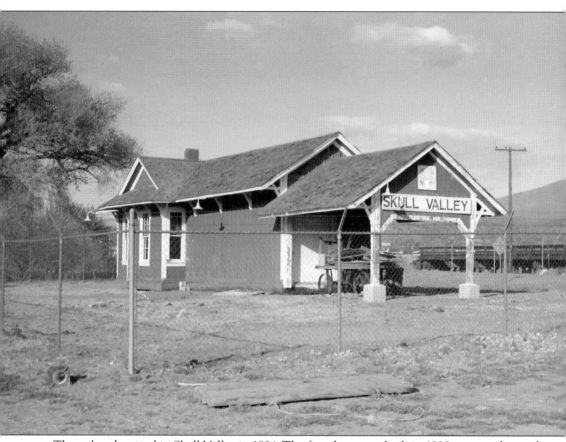

The railroad arrived in Skull Valley in 1894. The first depot was built in 1898 to serve the cattle, goat, and sheep ranches and the mining interests in the area. The present Santa Fe Depot, which was moved from Cherry Creek near Dewey in 1926, and the Rams Gate Section House (built in 1925 and moved in 1953) are now a historical museum supported primarily by donations and well worth a visit.

Five

SOUTH CENTRAL YAVAPAI COUNTY

Over the years, Black Canyon City, on Interstate 17, has been known as the Agua Fria Mining District, Goddard, Cañon, Rock Springs, and Black Canyon. The Rock Springs Store and Café, established in 1924 and famous for its pies, is still in operation today.

Cordes Station is three miles west of the Bloody Basin/Crown King interchange on Interstate 17. In 1883, German immigrant John Henry Cordes bought a stage stop and one section of land for $769.43. In 1886, he applied for a post office permit using the name Cordes. From the 1890s to the 1930s, Cordes Station was the major supply center for the sheep business in central Arizona. The store at Cordes Station is still in existence as an antique store operated by the Cordes family.

The first mines in the Bradshaw Mountains near Crown King were the Del Pasco and Tiger in the 1860s. In 1887, Illinois banker George P. Harrington invested in the Crowned King Mine, from which the town of Crown King derived its name. Today, there are many summer homes and camping facilities in Crown King and Horsethief Basin, and summer weekends are busy with events.

The town of Dewey-Humboldt, incorporated in 2004, is the result of two small rural communities combining to form a town. Both are adjacent to Highway 69. Dewey was originally a farming and ranching community. The Agua Fria River runs through the town. Humboldt (originally Val Verde) developed in the 1890s as a company-owned smelter town to serve the local mines.

Mayer is located in the foothills of the Bradshaw Mountains. It was founded and named by Joseph Mayer, who purchased the Big Bug Stage Station in 1881. Joe Mayer had his hand in almost every business in the area and was a true 19th-century entrepreneur. The town of Mayer has retained its rural, small-town, western flavor and many of its historic buildings. It is a great adventure to get off Highway 69 and experience what life might have been like in a Yavapai County town 50 years ago.

Mining began in the Black Canyon City area in earnest in the 1870s, as did farming and ranching. Over the next four decades, farming, ranching, and businesses slowly emerged as employers as mining declined. In 1920, the opening of the Kay Copper Mine brought a growth spurt, which in 1924 encouraged Ben Warner to establish the Rock Springs Store and Café, which are still in operation today. (Robert Cothern.)

Vladimir Albins shows off some celery from the D.J. Albins farm in Black Canyon City in this undated photograph. The Albinses are a legendary Black Canyon City family. Dimitri "D.J." settled there in 1929 and began farming. The Albins family has generously donated land to the community for a fire station, library, school, church, sheriff's substation, and a park. (Jeane Albins.)

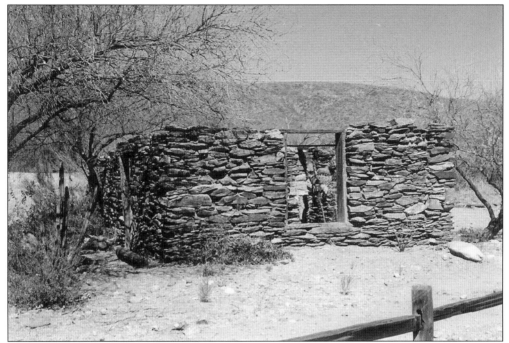

In 1871, Jack Swilling, an Arizona pioneer, entrepreneur, businessman, and all-around colorful character, built a stone cabin beside the Agua Fria River, which was also the first stage stop in the area. In the 1860s, Swilling had cleaned out the original Hohokam irrigation canals in the Salt River Valley to create a water source for settlement and irrigated farming that led to the development of Phoenix. (Robert Cothern.)

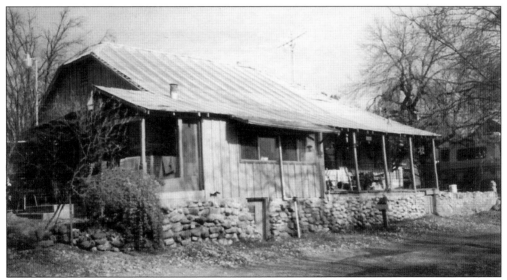

Jeff Martin built a boardinghouse in 1903 near the confluence of the Agua Fria River and Black Canyon Creek. He subsequently expanded his operation, adding a general store, restaurant, and post office. Martin became postmaster in 1912. His enterprise became known as Stage Stop, and the store still exists today in the same location. (Robert Cothern.)

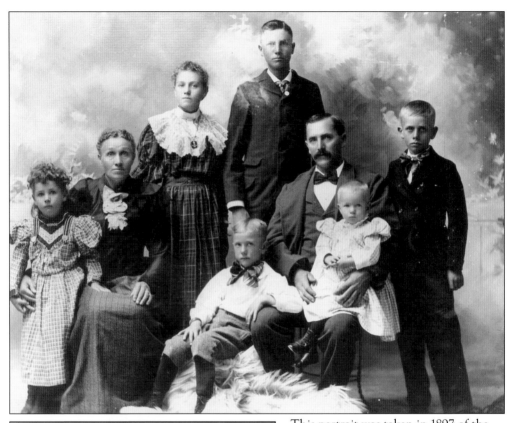

This portrait was taken in 1897 of the original Cordes family in Arizona. From left to right are Lucy Johanna Cordes, Elise (Lizzie) Cordes, Grace Sophia Cordes, Frederick James Cordes, Charles Henry Cordes, John Henry Cordes with Mynne Ann Cordses on his lap, and William (Bill) Harrison Cordes. (Cordes Family Collection.)

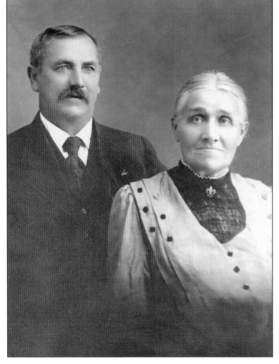

The year 1908 saw John Henry Cordes retire and move to Prescott. He had married Elise Schrimpf on October 30, 1880. This portrait of John Henry and Elise was taken in 1910. They would send five of their six children to Los Angeles Business College. The importance of education in the family continued, as many of their descendents would later become career educators in Arizona and elsewhere. (Cordes Family Collection.)

The year 1908 was also a big year for Charles Henry Cordes when he took over his father's business. Charles also married Mary Elizabeth Chastain on May 5 in Mayer. She was one of the first telephone operators in Yavapai County. Their acquaintance started on the telephone when Charles would make calls into Prescott. The telephone arrived at Cordes Station in 1905. (Cordes Family Collection.)

The store at Cordes Station was built in 1910. This business was one of the few stops on the Old Black Canyon Road from Prescott and Phoenix where one could buy supplies. This building burned in 1941, and a new structure was built on the same foundation. It was completed in 1943 and is still in existence today as an antique store. (Cordes Family Collection.)

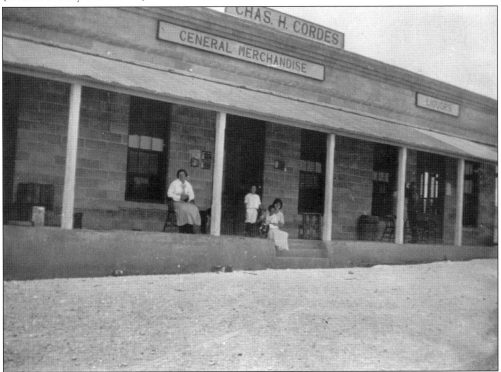

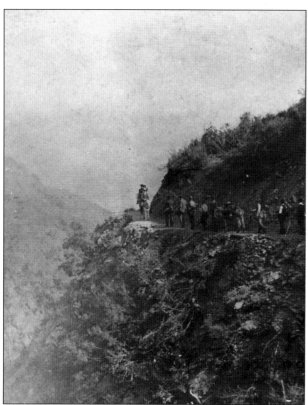

The first settlement in the Crown King area was Bradshaw City. Here, hard-rock miners leave their homes in Bradshaw City to walk to their morning shift at the mines about 1890. (Rollerton Collection.)

This is Luke's Mill around 1890. Luke had the mill moved from near Yuma in about 1877 to Bradshaw Basin. Over the years, the mill was updated and expanded into the Crowned King Mine's mill. Today, only the stonework survives, and the county road into Crown King passes through where the boilers and smokestack were once located. (Rollerton Collection.)

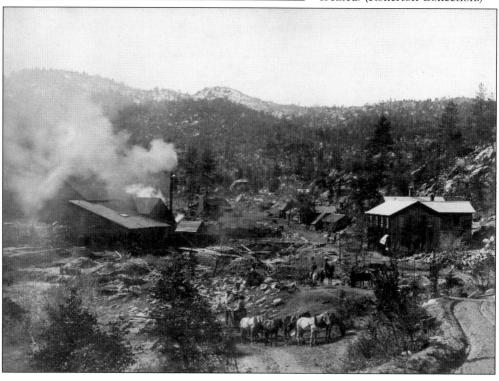

Here, Illinois banker George Patterson Harrington, who bought the Crowned King Mine in 1887, poses at one of the area mines around 1905. After the Crowned King Mine, Harrington managed the Tiger Gold Company and worked to establish the Harrington, Arizona, post office at the Ora Bella mining camp. (Rollerton Collection.)

The Bradshaw Mountain Railroad was often called "Frank Murphy's Impossible Railroad" because of its many curves, steep grades, and the use of four switchbacks to climb the mountain. Trains began arriving at the new Crown King Depot in May 1904. The station was destroyed by heavy snows in the 1930s, but the granite boulders, a recognizable landmark to locate the site of the depot, are still there. (Rollerton Collection.)

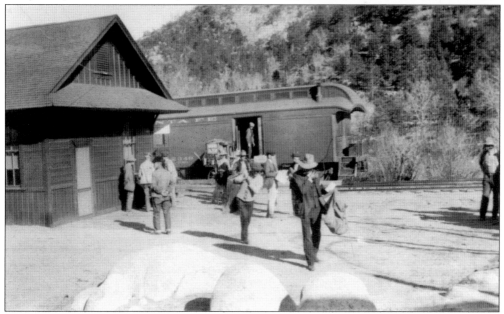

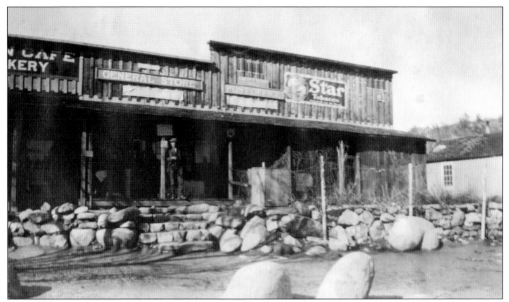

The Crown King General Store was built by the Bradshaw Mountain Railroad just across the flat from Crown King Station. During the Depression, the store was owned by Robert "Pat" Patterson. The structure was barely saved from a fire in April 1950. It is still open today. (Rollerton Collection.)

"Doc" Tyler is behind the bar in his Granite Saloon in Crown King around 1890. All that remains of this building is a stone foundation on the hillside behind the Crown King Store. (Sharlot Hall Museum.)

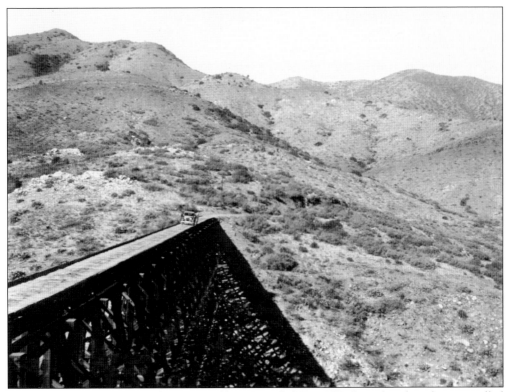

The mining boom days went bust as World War I ended. By 1927, the railroad tracks were pulled up, and the road opened for automobile traffic on the current road between Cleator and Crown King. Brave motorists could take this route to Crown King, driving on the railroad bed and trestles. Here, Wink Winker and his "Tonawanda" Ford make the crossing to escape the Phoenix heat. (Rollerton Collection.)

The Dewey-Humboldt area was first farmed in 1864 by King Woolsey. The ruins of Woolsey's 1883 stone house on his Agua Fria Ranch are located about halfway between Dewey and Humboldt on the Old Black Canyon Highway. This was the first Anglo building in the Dewey-Humboldt area. (Dewey Born Collection.)

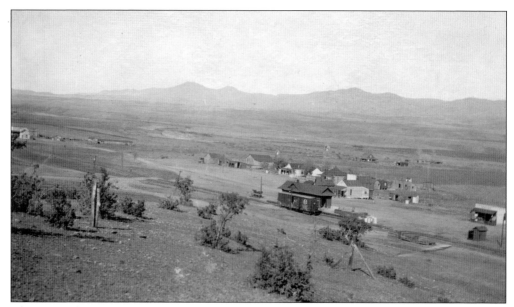

Cherry Creek is now known as Dewey. Looking east and slightly north, the Prescott & Eastern Railway station is shown in the center foreground with a boxcar parked on the siding. The P&E, a branch line of the Santa Fe, Prescott & Phoenix Railway, maintained depots at Cherry Creek, Huron, and Mayer. The land beyond the depot is the site of the former Young's Farm. (Sharlot Hall Museum.)

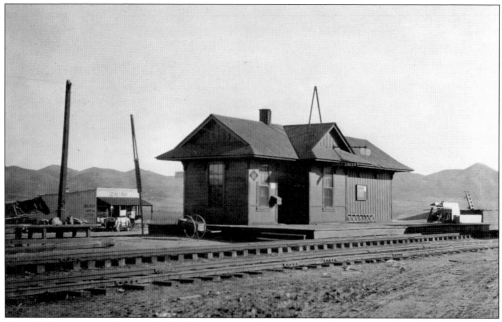

The P&E station at Cherry Creek Siding served the agricultural and livestock businesses of the Dewey area. The depot was built in 1898 and moved to Skull Valley in 1926. It now serves as a museum. The Dewey Bar is in the background to the left. (Sharlot Hall Museum.)

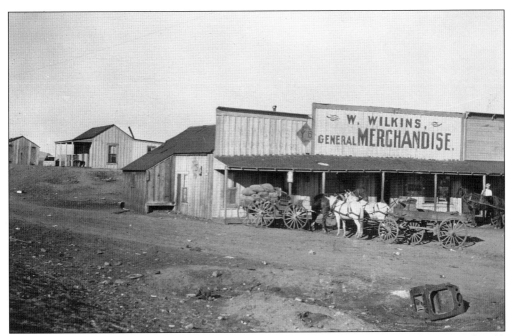

The Wilkins Store in Dewey served the surrounding farms and ranches. Many were nearly self-sufficient, but most anything the residents did need to buy could be found at the local mercantile. The wagons are loaded with what may be sacks of grain or seed. (Sharlot Hall Museum.)

Sharlot Mabridth Hall came to Yavapai County with her parents in 1882. They settled on a ranch near what is now Dewey. Here she is shown with her father, James Hall, at Orchard Ranch. A writer and poet, Sharlot told many of her stories of ranch life in *Poems of a Ranch Woman*. (Sharlot Hall Museum.)

As territorial historian, Sharlot Hall was the first woman to hold public office in Arizona Territory. She was appointed in 1909. As a young woman, she often visited the Territorial Governor's Mansion, where she listened to the stories of old Prescott told by judge Henry Fleury. In the 1920s, she moved into the Governor's Mansion and established Sharlot Hall Museum. (Sharlot Hall Museum.)

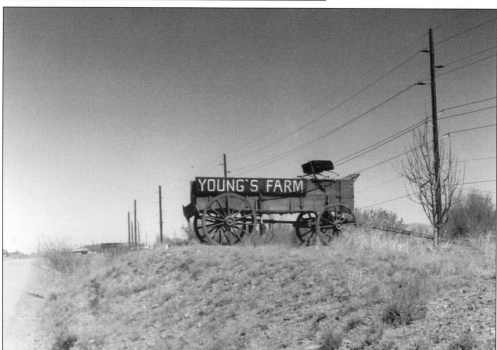

An old wagon advertises Young's Farm along the Old Black Canyon Highway (Highway 69). The farm was famous for summer sweet corn, an October pumpkin fest, and fresh holiday turkeys. Elmer and Lavera Young, the last owners of the property, were the only ones to raise and process turkeys in Arizona. Changes in the laws governing use of groundwater forced the Youngs to cease farming in 2006. (Dewey Born Collection.)

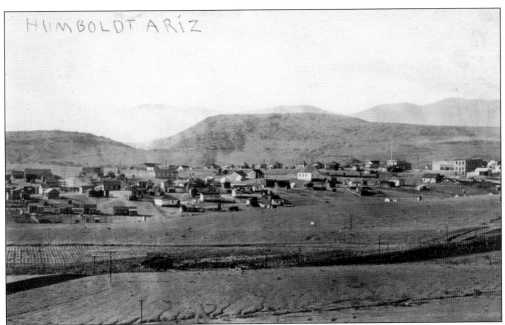

In 1899, Val Verde was created as a company town by the Val Verde Smelter Company. By 1904, Val Verde was owned by the Bradshaw Mountain Copper Smelting Company. When the post office was established in 1905, a new name was chosen for the town—Humboldt, after Baron Alexander von Humboldt, a scientist and explorer. The town and part of the company farm are shown here about 1905. (RPPC.)

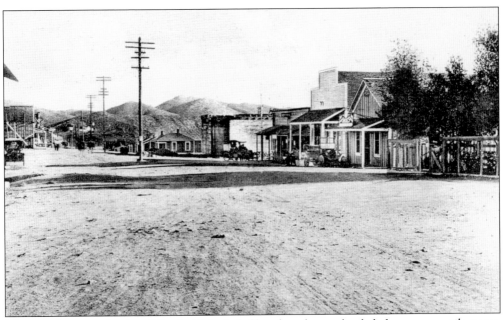

The main business district of Humboldt included hotels, a theater, bank, bakery, mercantile stores, assay office, drug store, ice plant, restaurant, saloons, a service station, and churches. In 1907, the population was about 1,000. The post office is at the far right in this c. 1920 image. Some of the buildings constructed in the late 19th century are still standing. (Sharlot Hall Museum.)

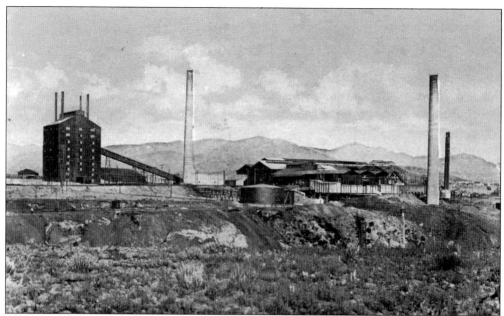

The Arizona Smelting Company smelter was constructed in 1906, following a 1904 fire that destroyed the Val Verde Smelter. The new smelter could process 1,000 tons a day. In 1917, more than two million pounds of copper and lead, mostly from the Desota and Blue Bell Mines, left the smelter each month. (C.T. American Art Postcard.)

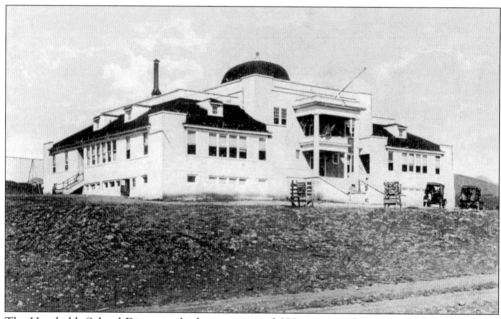

The Humboldt School District, which encompassed 320 square miles, was established in 1906. A one-room school was built in 1908 for 43 students. By 1926, a larger school was completed and was the pride of the community. Unfortunately, the three-story, domed structure had a large mortgage, and Humboldt had a shrinking economy and population. The school burned to the ground on June 3, 1932. (C.T. American Art Postcard.)

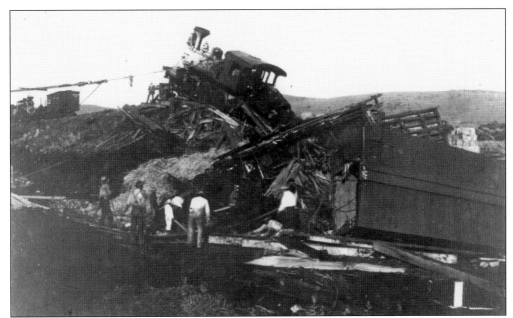

Train accidents were very common in the late 19th and early 20th centuries. Floodwaters washed out the base and ballast, track failed, engines ran away from the conductors, and trains collided with each other. This spectacular wreck of *Old No. 7* occurred in Humboldt in the 1920s.

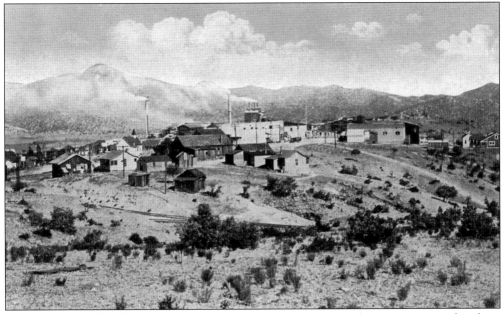

Between 1922 and 1937, depressed mineral prices, intermittent smelter operations, a shrinking population, and the Great Depression had a severe impact on Humboldt. By 1930, the population was about 300. The smelter closed for the last time in 1937. A welcome surge in the economy had occurred when the Iron King Mine reopened in 1934. But an economic depression continued through the 1950s. (C.T. American Art Postcard.)

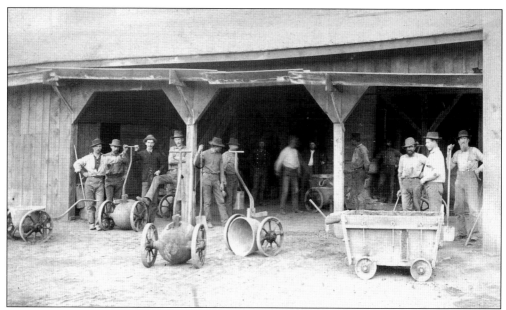

Mining was a major economic engine of not only Mayer but of most of Yavapai County from settlement until the Great Depression of the 1930s. Mining activities continue today in Mayer, including the Mayer Onyx Mine, which was originally owned and operated by Joe Mayer and William O. (Buckey) O'Neill. This is the interior of one of the buildings at the nearby Boggs Smelter in 1888. (Photograph by E.M. Jennings.)

This 1940s view of Central Avenue in Mayer is looking southeast toward the railroad depot and water tank. The Big Bug Stage Stop, where Joe Mayer's daughter, Winifred Mayer Thorpe, lived until the 1980s, was on the left-hand side of the street northwest of this location. Included in this photograph is the Highway Garage, with an advertising sign for Quaker State oil conveniently nailed to a nearby tree.

This typical scene of a Mayer street was photographed in 1941. The huge Fremont cottonwood trees that line many of Mayer's streets are watered by nearby Big Bug Creek, which was a year-around stream in Joe Mayer's day, but today is a seasonal stream. In fact, it flooded out the Mayer family their first year in Mayer and still occasionally floods.

The Mayer Business Block was built on Central Avenue by Joe Mayer and housed his Mayer Mercantile, the Mayer Saloon, and the barber shop. The bar from the Mayer Saloon is now a part of the Pioneer Arizona Living History Museum near Anthem. The Mayer Business Block is listed in the National Register of Historic Places.

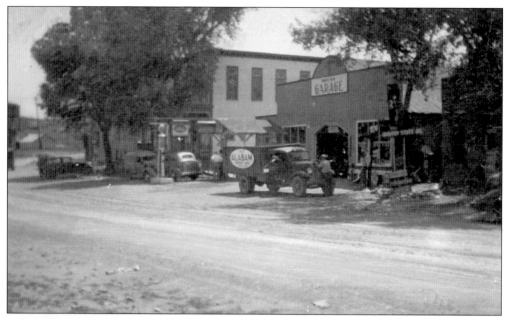

Many of Joe Mayer's enterprises were successful and made him a wealthy man in property, if not in cash. The Mayer Hotel was one of his first enterprises. Originally, it housed a restaurant and mercantile business. Later, one of several gas stations in Mayer was built next door—after all, it was a long way to Prescott or Phoenix to buy gasoline. This photograph was taken on September 24, 1937.

Although the gas station next door to the Mayer Hotel no longer stands, and the hotel has been converted into apartments, residents still sit on the front porch and watch the world go by. This is a view of the Mayer Hotel looking across the street to the Mayer Business Block in the early 1950s. (Sharlot Hall Museum.)

Six

EASTERN YAVAPAI COUNTY

Originally, Rimrock was known as Beaver Creek, with homestead ranches and farms along its banks, but it later became Rimrock because of its rimrock vistas around the tops of mesas.

An area to the south gradually became popular dude ranch country, luring the wealthy who bought existing properties. Ultimately, a Phoenix television personality bought a spread now named Lake Montezuma because of its proximity to historic Montezuma Castle and Well.

For three centuries, the Verde River was home to the Yavapai and Apache Indian tribes, two separate groups with completely different languages, but that changed with the arrival of the American military's Fort Verde, which eventually forced them from their homeland to other locations. The military later abandoned Fort Verde and opened it and its reservation to homesteaders. Even though sulfurous smelter smoke and the Great Depression all but drove the area's farmers and ranchers to their knees, Camp Verde has remained a community built on hard work and close ties to family and friends.

Clarkdale has the distinction of being Arizona's first master-planned community. William Andrews Clark saw the wealth in Jerome's underground riches and in 1888 began development of the United Verde Copper Company. When Jerome's mining converted to open pit, he had to locate the smelter and buildings elsewhere. He chose the Clarkdale site, named it after himself, and provided all the amenities—telephones, telegraph, sewer and electrical services, wide streets, business and professional buildings, and dwellings that are now historic.

Cottonwood, too, has a rich history of American Indian culture, and its roots relate to the mining and ranching industries as settlements grew up around the United Verde Copper Company. In 1917, James Douglas began construction of the United Verde Extension Company and located a smelter in Verde, later to become Clemenceau. Over time, he donated land and built the Clemenceau Public School and the Clemenceau Airport. The smelter ceased operations in 1936, and in 1960, Cottonwood incorporated Clemenceau.

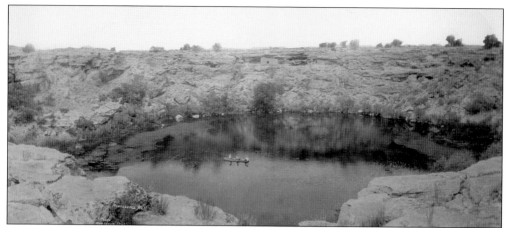

Montezuma Well was a Sinagua population center, as shown by the ruins in the cliff face. Traditional tribal beliefs say that the Yavapai people emerged from the earth here. Spaniard Antonio Espejo visited in 1583, followed by American fur trapper Antoine Leroux in 1854. In 1870, Wales Arnold bought the well. William Beriman Back acquired the property in 1888 and in 1947, following his death, Montezuma Well became part of Montezuma Castle National Monument. (Cowan Collection.)

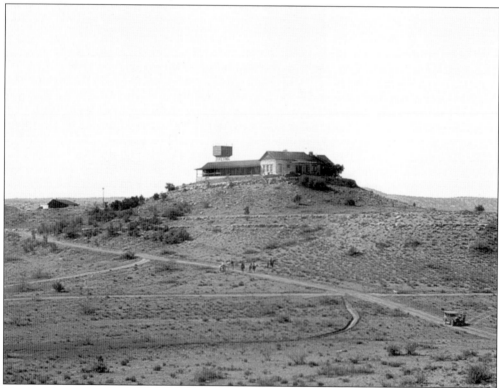

Virginia Finnie, born at Soda Springs in 1901, married Wickenburg cowboy Romaine Loudermilk in 1928. That year, the couple, along with aviator Russell Boardman, opened Rimrock Lodge guest ranch. The Rimrock Post Office was established at the ranch for guests and local residents. This 1928 photograph was taken by Santa Fe Railway photographer Edward Kemp, as most guests came into Clarkdale, Prescott, or Flagstaff via the Santa Fe. (Judy McBride.)

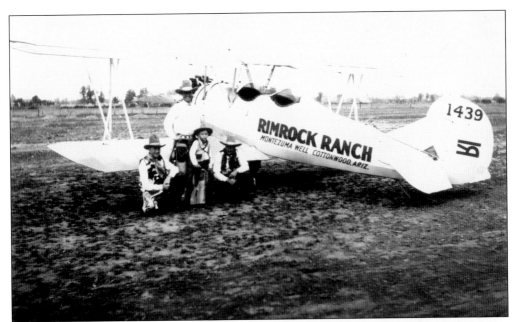

Russell Boardman (center) was a partner in Rimrock Ranch. Guests could fly into the Rimrock Airport, the oldest continuously used landing strip in Arizona, in this bi-winged Travel Air. The wealthy bought ranches around Beaver Creek, and in 1957, with the coming of the Black Canyon Highway, the largest of these ranches was subdivided and called Lake Montezuma. This photograph was taken for the 1928 Porter's Saddle Company Catalog. (Sue Scott.)

Beaver Creek School was the social center of the community and has been in several locations over the past 120 years, but each one was destroyed by fire. It was built of stone at its current location in 1932. The cost was paid through a bond. Dances were held to pay off that debt, with half the money paid to the band and the other half to the bond. (Cowan Collection.)

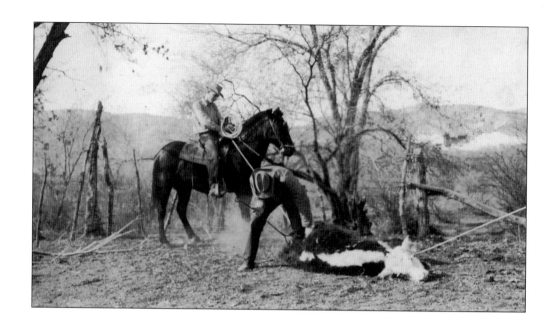

These two c. 1930 photographs show branding time on the Monroe Ranch below the salt mine near Camp Verde. In the territorial period, the Monroe family settled along the Agua Fria River and Ash Creek before moving to the Verde Valley. Above, Ralph Monroe Sr. is putting his brand on a Monroe calf, roped and thrown by son Ralph Jr., seen in the photograph below. (Greg Back.)

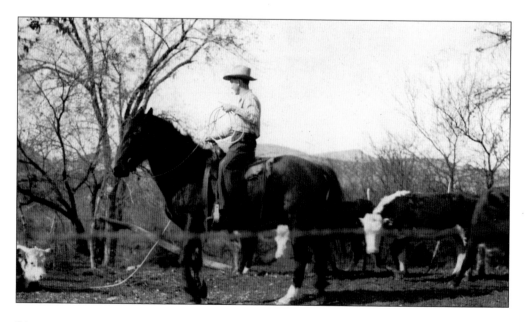

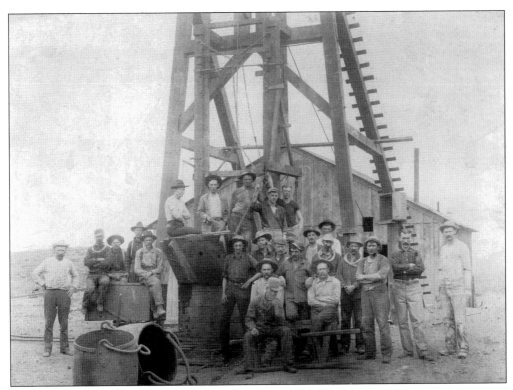

Camp Verde enjoyed brief prosperity from mining when an ancient salt deposit, worked by the Sinagua Indians some 700 years earlier, was tapped again in 1923. The salt mine shipped 130 tons a day to the West Coast, but foreign competition forced its closure in 1933. The salt deposit formed when an ancient lake that covered the valley floor between 10 and 2.5 million years ago dried up. (Steve Ayers.)

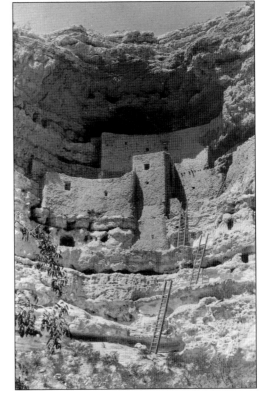

One of the best-preserved cliff dwellings in the Southwest is Montezuma Castle, located on the banks of Beaver Creek in Camp Verde. It became one of America's first four national monuments in 1906, shortly after Congress passed the Antiquities Act, and is one of hundreds of pueblos and ancient habitation sites that tell a story of centuries of occupation along the banks of the Verde River and its tributaries. (Steve Ayers.)

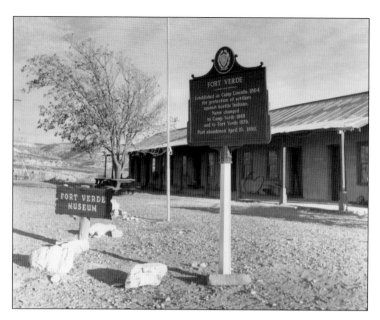

Fort Verde became a museum in 1956 thanks to the efforts of a group of citizens known then as the Camp Verde Improvement Association. The association appointed a committee responsible for restoring the fort and creating a museum, which became the Fort Verde Museum Association. The State of Arizona bought Fort Verde from the association for $1 in 1970 and turned it into a state park. (Steve Ayers.)

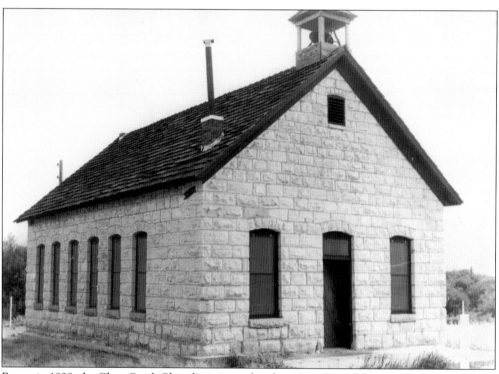

Begun in 1898, the Clear Creek Church was completed in 1903. One of the valley's oldest surviving churches, it was constructed of white limestone quarried from the surrounding limestone hills. It served the community until 1912, when it was abandoned. Afterward, the building functioned as a school and a cannery. Eventually, the Burbacher family bought it and donated it to the Camp Verde Historical Society. (Steve Ayers.)

Begun as a sutler's store in 1871 to serve the soldiers at Fort Verde, the business eventually evolved into the Wingfield Commercial Company. With the motto "Everything Under the Sun," it was an institution in the Verde Valley for decades, serving customers throughout the area. When it closed its doors in 1976, it was one of the oldest continually operating businesses in Yavapai County. (Steve Ayers.)

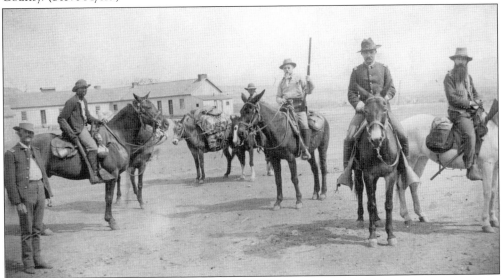

Often short of rations and persistently ill-equipped for the task they had been sent to do, soldiers assigned to Fort Verde in its early days lived a miserable existence. That changed in 1870, when Gen. George Crook was made the commander. He and his soldiers made life so difficult for the Yavapai and Apache that by summer 1873, almost all of the bands in the area had surrendered. (Steve Ayers.)

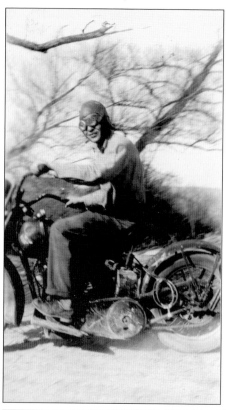

As Yavapai County progressed from horses to horseless carriages, Harley-Davidson played an important part in the life of many a young Yavapai County man. Harleys were cheap, easy to start, and very maneuverable on rocky back roads. Notice the large back sprocket on this vintage Harley ridden by Basil Back below Camp Verde. This sprocket allowed the machine to go very slow relative to the engine speed. (Greg Back.)

The welcoming confines of the Verde Valley have long been a haven for Native American cultures. The pre-Columbian Puebloan, Hohokam, Sinagua, and Yavapai people left evidence of their presence in petroglyphs and ruins scattered across the Verde Valley and on hilltops up and down the river. Increased understanding of these rock art symbols over time suggests that they contain sun calendars indicating planting and harvest cycles. (Sharlot Hall Museum.)

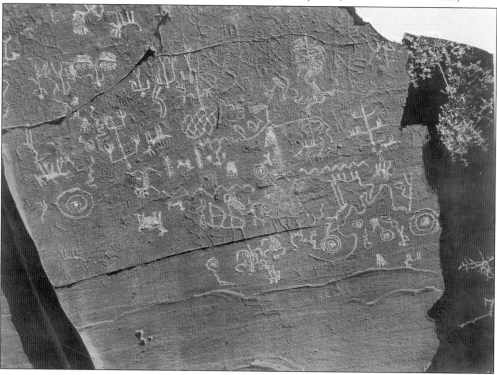

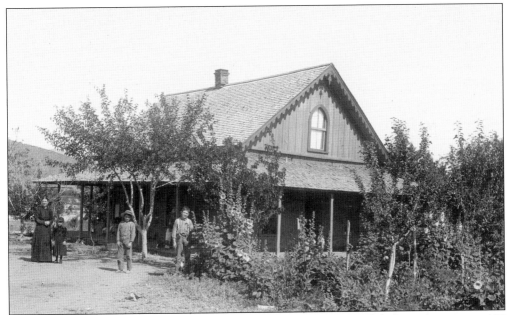

Pres. Abraham Lincoln signed the Homestead Act in 1862, offering adult American citizens 160 acres of land in the American West free if they would build a house, use at least 10 acres of it for agriculture, and manage to live on it for three years. The great weather, rich soil, and tall grass in Yavapai County and particularly in the Verde Valley resulted in a torrent of settlers. (Sharlot Hall Museum.)

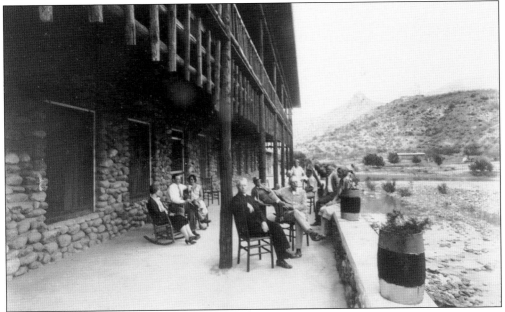

During the 1930s, Yavapai County tourism boomed. The romance of the American West was promoted by the Santa Fe Railway, which might deliver an eastern traveler into train stations in Prescott or Clarkdale. From there, tourists were driven in elegant motor coaches into wilderness locations such as Verde Hot Springs, which promoted the healthful aspects of soaking in the 100-degree mineral water along the Verde River. (Sharlot Hall Museum.)

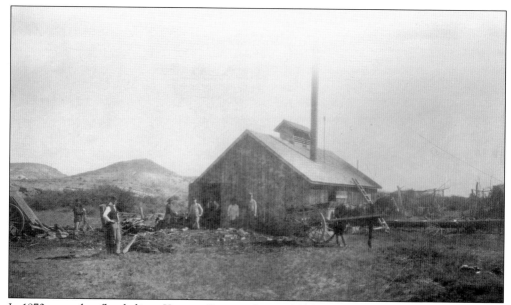

In 1870, as settlers flooded into Yavapai County, the need for bigger and better military installations grew as well. The decision was made to move Fort Lincoln, in the Verde Valley, and rename it Camp Verde. Between 1871 and 1873, twenty-two buildings were erected. The walls were made of adobe, but the roofs and interior framing were made of boards from a sawmill in the Black Hills. (Sharlot Hall Museum.)

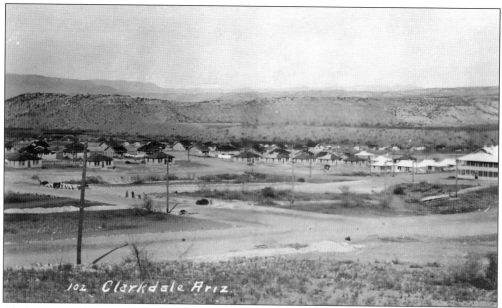

Clarkdale, established by mining magnate William Andrews Clark, remained in various company hands until 1957, when residents decided they wanted to shape their own destiny, and on July 1 of that year, the Yavapai County Board of Supervisors granted the town its certificate of incorporation. (RPPC.)

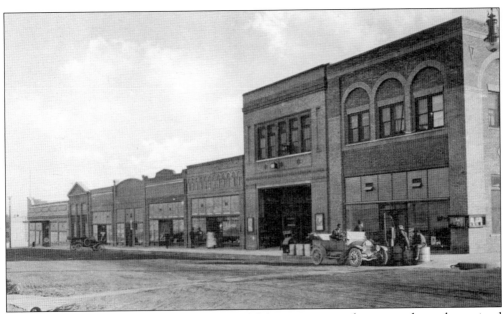

William Andrews Clark, the founder of Clarkdale, was a man of vision and was determined that his town would not grow haphazardly. He developed a master plan, with the main townsite located on a ridge overlooking the industrial smelter complex. The plan allowed for residential homes for both upper and lower incomes, a commercial area, an administrative center, schools, recreational and cultural facilities, and parks. (Clarkdale Pharmacy Albertype.)

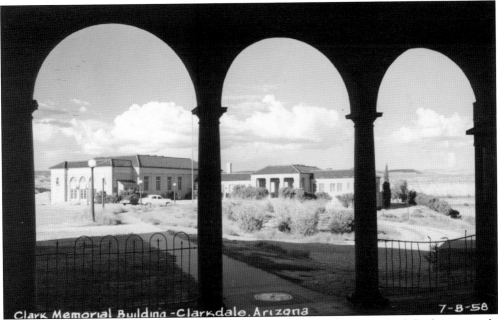

Clark Memorial Building - Clarkdale, Arizona 7-8-58

When William Andrews Clark planned for the town that bears his name, he left a lasting mark. Clark's most notable legacy today is the Clark Memorial Clubhouse and Memorial Library, which were constructed in 1927 for the grand sum of $90,000. Their style reflects the Spanish Colonial architectural theme of the town's business district. Today, the buildings are listed in the National Register of Historic Places. (RPPC dated July 8, 1958.)

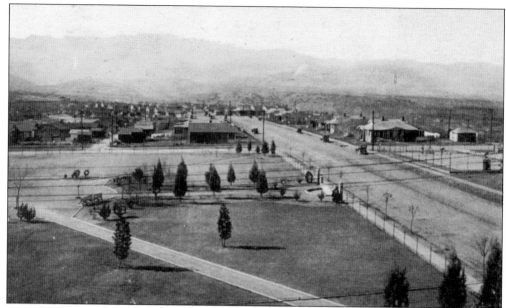

As planners laid out Clarkdale's streets, they wanted names that would help newcomers and visitors get around conveniently. Main Street divides the town, running west from the Verde River. As they picked names for parallel streets, they chose to follow the Salt Lake City method, designating First North Street, First South Street, and Second North Street, for example. (Clarkdale Pharmacy Albertype.)

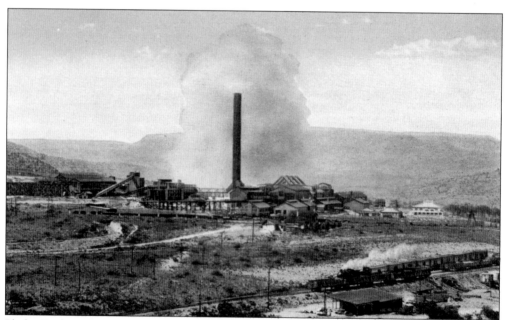

Phelps Dodge Corporation, hearing of Jerome's rich ore deposits, investigated claims but decided they were not worth the investment. However, William A. Clark came forward and grabbed the opportunity. He developed the United Verde Copper Company and turned it into one of the richest copper mines in the world. The company processed copper that was brought from Jerome from 1913 until 1953. (C.T. American Art postcard.)

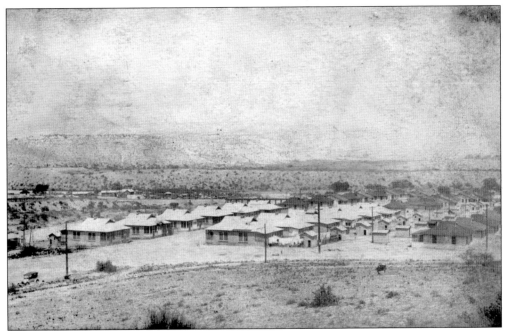

Clarkdale's climate is normally moderate, but on occasion a coating of white, such as seen in this historic photograph, surprises residents. This is exactly what happened in December 1967 when residents awoke to what would become known as one of the more severe snowstorms in Arizona history, which all but buried the Verde Valley, crippling it for more than a week. (RPPC dated October 4, 1923.)

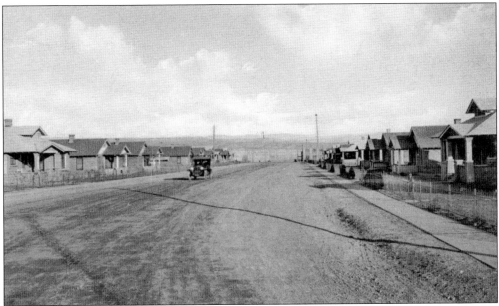

An automobile from the 1920s traverses one of the wide boulevards of Clarkdale's residential neighborhoods. As a company-owned, planned community, Clarkdale had many amenities for its residents, including a city utility system, stylish bungalows, sidewalks, and neighborhood parks. (Clarkdale Pharmacy Albertype.)

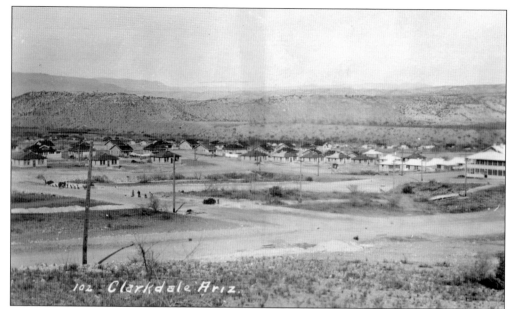

When William Andrews Clark's ambition to have a town named for him came to fruition on planners' drawing boards, Clarkdale emerged, first with construction of the smelter in 1912 and then temporary buildings for a store and a post office. Soon after, three streets of low-cost living quarters sprang up, and the remainder of the town was divided into two sections, now known as Lower and Upper Town. (RPPC.)

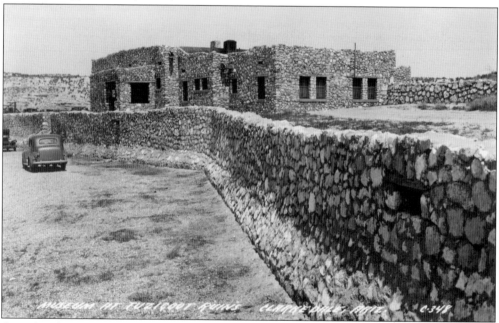

Out-of-work copper miners learned new skills when they got jobs excavating the ruins of the Tuzigoot National Monument in 1933 and 1934. They uncovered and reconstructed the 110-room pueblo as part of the New Deal. The ancient village was built by the Sinagua people, beginning in approximately 1000 AD. The Sinagua were agriculturists with trade connections that spanned hundreds of miles around them. They left here around 1400. (L.L. Cook Co. RPPC.)

This 42-acre Yavapai County wonder lies on the northeast border of Clarkdale and is operated by the National Park Service. The Tuzigoot National Monument features a museum, is surrounded by hiking trails, and borders the Tavasci Marsh, which the National Audubon Society has designated an important birding area. (RPPC by Frasher.)

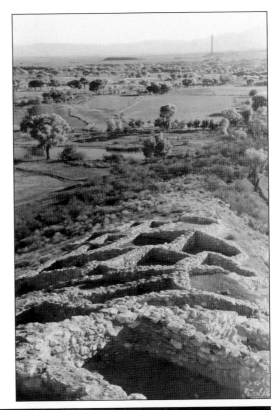

Because William Andrews Clark decided upon open-pit mining in Jerome, he had to establish mining operations elsewhere, thus the birth of Clarkdale at the base of Cleopatra Hill a short distance away. This image shows the view coming into Clarkdale on Highway 89A from Jerome, probably in the 1940s. Note the smokestacks at the smelter. (RPPC by Frasher.)

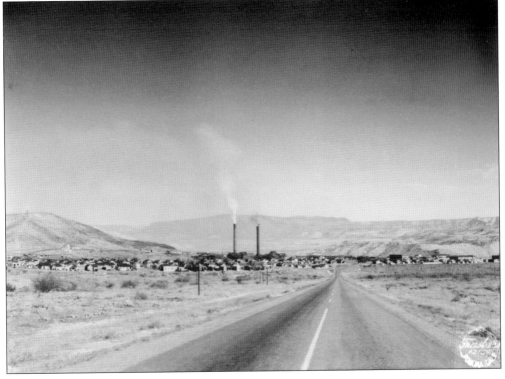

The Verde River begins below the dam that catches water from the Big Chino Wash and Williamson Valley Wash at Paulden in Yavapai County. The Verde flows for more than 170 miles through private, state, tribal, and US Forest Service lands before its convergence with the Salt River in Maricopa County. Camp Verde, Clarkdale, and Cottonwood sit along its banks. (C.T. Art–Colortone postcard.)

Just outside Clarkdale sits Peck's Lake, once a premier recreation area for workers at Phelps Dodge mines in nearby Jerome during the copper-mining heyday in northern Arizona. The mines shut down in the 1950s, and the lake has been closed in recent years. In 2002, the Audubon Society designated it an important birding area. (Sharlot Hall Museum.)

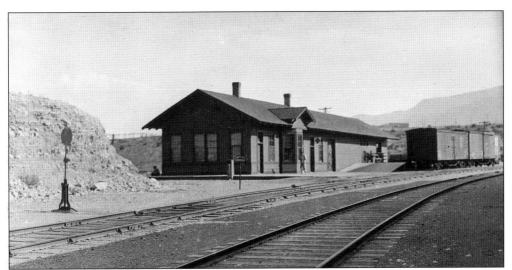

When William Andrews Clark, owner of the United Verde Copper Company, planned the Clarkdale community for smelter workers, he spent $1,286,061 to build the 38-mile-long Verde Valley Railway from Drake into Clarkdale. Locals called it the "Verde Mix," because of the combination of passengers and freight on this rail line. This station was built in Clarkdale near the terminus. (Sharlot Hall Museum.)

The Verde Tunnel & Smelter Railroad (VT&S) was the only short line in the United States to operate huge Mallet compound locomotives that could negotiate the steep grade between Jerome and Clarkdale. This combination car ran on the VT&S Railroad, which ran 11 miles from Clarkdale to Jerome, delivering supplies to Jerome and hauling ore from Hopewell to Clarkdale. (Sharlot Hall Museum.)

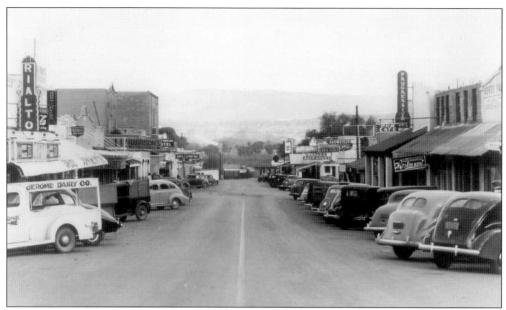

In 1885, the first post office was established with the name of Cottonwood, Arizona Territory. As time went on, there was a ready market for agriculture for both the military of Fort Verde and Jerome's copper-mining camp. In 1908, pioneers Charles Stemmer and Alonzo Mason created Main Street by using a team to pull a drag through the brush. Today, people call it Old Town Cottonwood. (Clemenceau Heritage Museum.)

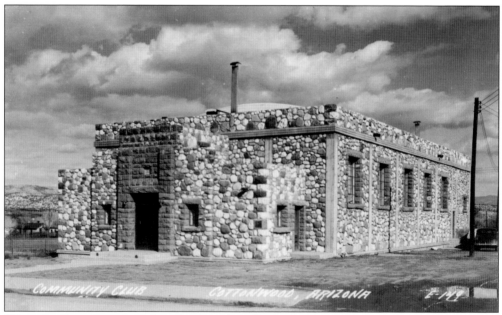

When the Great Depression hit, the United Verde Copper Company closed down its smelters in Clarkdale and Clemenceau in the summer of 1930, and hundreds of miners and smelter workers lost their jobs. Cottonwood began to benefit from work-relief programs of the federal government that rebuilt area bridges. In 1939, the Cottonwood Community Civic Club building was erected through the efforts of the Cottonwood Civic Club Organization. (L.L. Cook Co. RPPC.)

Cottonwood's Hopi Court, seen in this 1950s photograph, surely attracted guests because it advertised itself as air-conditioned and had radiant-heat floors, making it a desirable place to stay in both the summer and winter months. (Western Ways RPPC.)

The Cottonwood Hotel, a standout because of its unique Toltec Indian architectural style, dates to 1917 when Antonio and Mary Giordano built the icon, which had a clothing store on the ground floor and the hotel upstairs. It burned to the ground in the 1925 Cottonwood fire but was rebuilt to safer standards. Celebrities, including Elvis Presley and John Wayne, could once be spotted here. (Karen Leff.)

Clemenceau was a company town built in 1917 to serve the new smelter that James Douglas Jr. built for the United Verde Extension Mine in Jerome. When the smelter closed in 1936, most residents picked up and left. Today, Clemenceau is part of incorporated Cottonwood, and this building, the Clemenceau Public School, houses the Clemenceau Heritage Museum. (Clemenceau Heritage Museum.)

Ray Manley, who was born in 1921 in Cottonwood, had a passion for photographing Arizona. People of the Verde Valley knew him for his exquisite images of the red stone formations. The work of the world-renowned photographer and artist appeared on the pages of *Life*, *Look*, *The Saturday Evening Post*, and *National Geographic* and in his own books. (Sharlot Hall Museum.)

Seven

NORTHEASTERN YAVAPAI COUNTY

As the late Ted Edmundson writes in *Jerome*, "It's the darndest place you have ever seen / Cause it's slidin' down the mountain. Every day they take a countin' / Find they're closer to the valley than they were."

Known as the "wickedest town in the west," Jerome is a copper mining town, and its colorful history and independent spirit will forever be tied to the grueling work of mining a billion dollars' worth of minerals from the Black Hills of central Arizona. Two men were instrumental in the founding and prosperity of early Jerome: William Andrews Clark, the "Copper King," of the United Verde Copper Company; and James Stuart Douglas, "Rawhide Jimmy," owner of the Little Daisy and the United Verde Extension Mines. Jerome was named after the family of New Yorkers Eugene and Paulina Jerome. Around 1929, Jerome's population was estimated at 15,000. By the mid-1950s, the population was down to about 100. But the town did not die, and today Jerome is still "slidin' down the mountain." It is a national historic landmark and a community filled with history, talented artists, and independent spirits.

Sedona is mostly about red rock formations—but that is not all. The scenic wonders must have impressed pioneers in the 19th century, because life was not easy miles from anywhere with no roads. Oak Creek, one of Arizona's few streams that run all year, made farming possible. Cattle ranching was important from the earliest days, and even until 1998, there was still a working ranch in Sedona. Sedona's red rocks made a perfect background for almost 100 motion pictures. During the golden age of Westerns from 1923 through the 1950s, millions of people saw Sedona's unique landscape on the silver screen. Artists were attracted too. In 1950, people like Nassan Gobran and Max Ernst founded the Sedona Art Center. Today Sedona is one of the world's great art communities. Sedona's red rocks, weather, fine galleries, and shops attract millions of worldwide visitors annually. Oak Creek Canyon and the Secret Mountain Wilderness are a mecca for hikers; others enjoy Jeep and air tours.

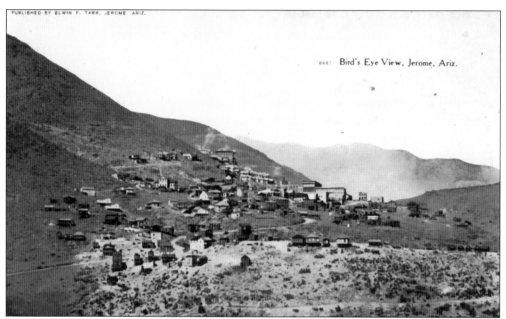

Bird's Eye View, Jerome, Ariz.

Initially a cluster of shacks inhabited by miners, by 1882 the little copper camp eventually had a name, Jerome. In the same year, the United Verde Copper Company was organized in Jerome, and the railroad reached Ash Fork. Jerome was incorporated in 1899, thirteen years before Arizona became a state. This c. 1900 bird's-eye view of Jerome is by Elwin Tarr.

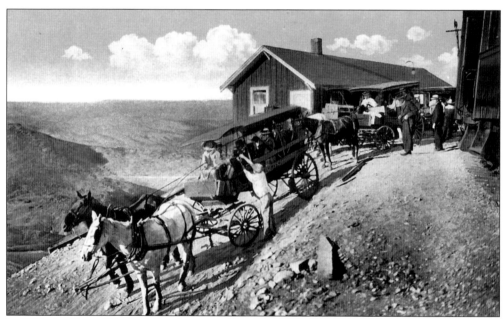

In 1893, the United Verde & Pacific narrow gauge railway reached Jerome from Jerome Junction, a 27-mile trip with 28 bridges and 187 curves. The arrival of the railroad in Jerome opened up the area to all travelers. Once the train arrived at this United Verde & Pacific depot (1905–1917) above the town, Boney Hughes's hacks took the passengers on the wild, one-mile trip down to Jerome. (C.T. American Art postcard.)

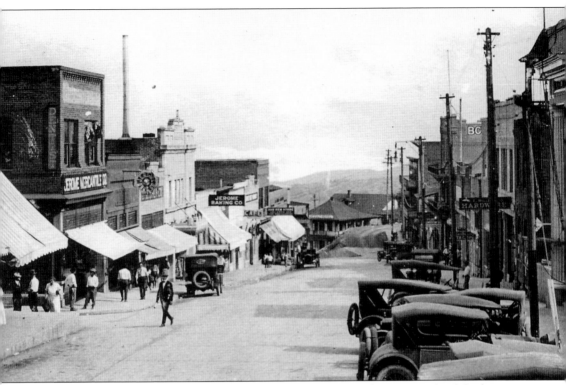

Jerome was the victim of four major fires from 1894 to 1899. Each time, much of the business district was lost. In addition, there were mine fires, one of which lasted for 20-plus years, and mine explosions. One of the reasons for incorporation of the town was to provide a water system. The left-hand side of this block of Main Street was destroyed by an underground mine explosion in 1937. (Jerome Drug Co. Albertype.)

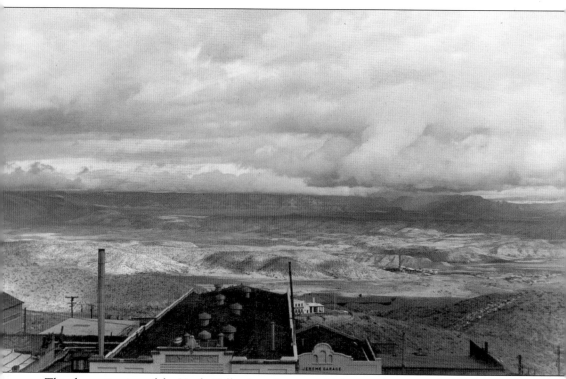

This dramatic view of the Verde Valley from Jerome, which was taken around 1920 from in front of the Lyric Theater, shows Jerome's relationship to the Verde Valley some 2,000 feet below. Part of the Douglas Mansion above the UVX Mine can be seen to the right of the Jerome Garage. The Douglas Mansion is an Arizona state park. The red rocks of Sedona are in the far distance. (Sharlot Hall Museum.)

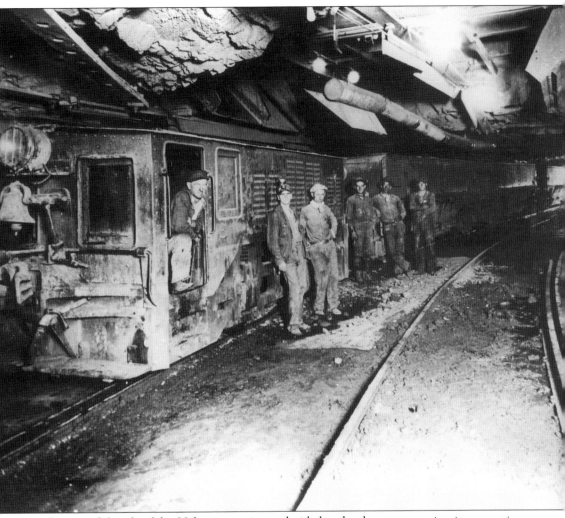

By the second decade of the 20th century, it was decided to develop an open-pit mine operation where the Jerome Smelter was located. This entailed moving the smelter and the United Verde & Pacific Railway five miles down the mountain to a new town, Clarkdale. An ore transfer system known as the Hopewell Haulage Railroad was constructed. This is the two-track electric line within the 7,200-foot-long Hopewell Tunnel about 1920.

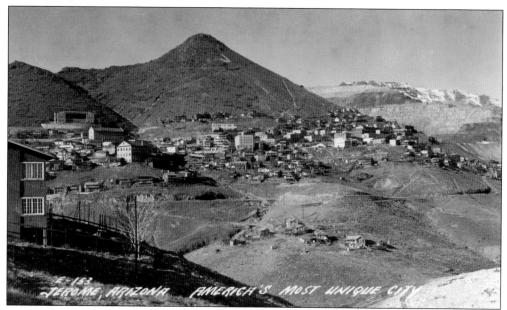

In their heyday, the mines were running three shifts a day. Boardinghouses rented rooms by shifts, with three men to a room, each laboring a different shift. The mines were worked by men from all over the world, including China, France, Ireland, Italy, Japan, Mexico, and the Baltic countries. As the Great Depression took its toll, the mines played out, jobs ended, and the population dropped dramatically. (L.L. Cook Co. RPPC.)

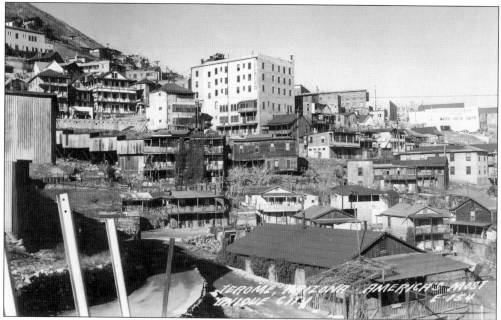

By the 1940s, many of Jerome's buildings were vacant. Today, many of these structures no longer exist. Built on a 30-to-35-degree slope and sitting on miles of mine tunnels, Jerome was a difficult place to keep buildings on their foundations. The sliding jail, a popular tourist attraction, is a good example of the propensity of Jerome's structures to be "slidin' down" Cleopatra Hill. (L.L. Cook Co. RPPC.)

Gradually, Jerome became a near ghost town. With a peak population in 1929 of 15,000, Jerome was the fourth largest city in Arizona. The 1932 population was down to about 5,000. Jerome's lowest population was around 50, in the 1950s. This sign was prominent at the entrance to Jerome in the 1960s. Today, Jerome is a ghost town no more and is filled with creative and welcoming residents, shopkeepers, and entrepreneurs.

This 1960s overview of Jerome shows just how visible the town is when viewed from the Verde Valley. At night, as a contemporary postcard states, it "appears to be hitched to the stars." The town can be seen from quite a distance to the east, but coming from the west over Mingus Mountain, it suddenly appears around a curve without much warning, and Jerome, the Verde Valley, and the red rocks of Sedona come into view. (Postcard distributed by Bob Bradshaw.)

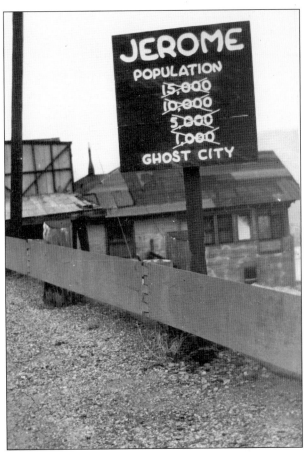

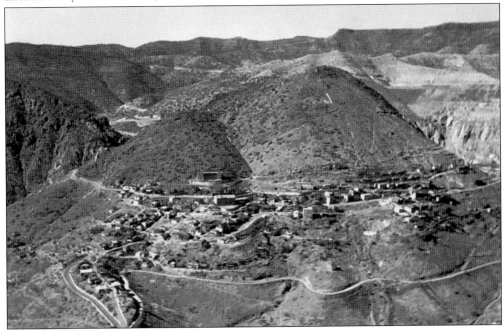

The approach to Sedona in the early days was an adventure over practically nonexistent roads. Even the Verde Valley was mostly inaccessible except by railroad until after 1930, when Oak Creek Canyon was opened to automobile traffic. State Highway 79 (now Highway 89A) from Flagstaff to Sedona winds through Oak Creek Canyon with spectacular views of the canyon walls and the creek below. (C.T. Art–Colortone postcard.)

Sedona's early pioneers had a hard life. Most were subsistence farmers who raised vegetables and corn for their own tables and sometimes had a little left over to sell. Lacking ready access to hardware stores, they used ingenuity to make things they needed. They dug ditches to irrigate their small fields and gardens, and hunted wild game and fished in Oak Creek. (Sedona Historical Society.)

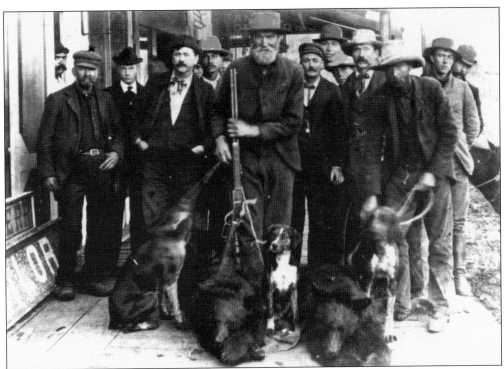

A colorful Sedona pioneer was "Bear" Howard, who came here after he escaped from a California jail; he had killed a sheepherder in a fight. He carried a bullet in his chest as a souvenir of the Mexican War, in which he fought under Sam Houston. Howard lived mostly by hunting bears and mountain lions and selling meat and hides to loggers and railroaders in Flagstaff. (Sedona Historical Society.)

In 1965, Joe Beeler (left) meets with, from left to right, Charlie Dye, John Hampton, George Phippen, and Robert MacLeod over a few beers at the Oak Creek Tavern in Uptown Sedona and founded the Cowboy Artists of America. Since its inception, this exclusive organization of artists has been dedicated to portraying the lifestyles of the cowboy and the American West as it was and as it endures. (Sedona Historical Society.)

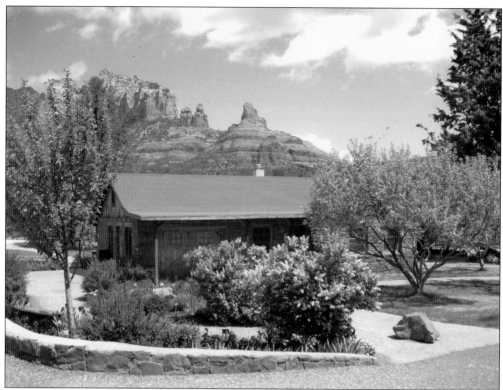

Historical Jordan Ranch is located near Uptown Sedona. The Jordan family were fruit farmers and raised primarily apples and peaches. Their home and apple barn are now open to the public and are listed in the National Register of Historic Places. With a comprehensive research library, excellent historical displays, and great events, the Sedona Historical Society, which is housed at Jordan Ranch, is well worth a visit. (Sedona Historical Society.)

The Schuermans grew grapes near Red Rock Crossing and made wine. Sedona's produce fed the miners in Jerome and the loggers and railroaders in Flagstaff. Fruit orchards grew into an industry, supplying apples and peaches to all parts of Arizona. The Jordans and Pendleys shipped apples overseas to troops in World War II. George Jordan's apple barn is now the Sedona Arts Center. (Sedona Historical Society.)

Almost 100 movies have used Sedona's red rocks—such as Coffeepot Rock, Bell Rock, and Cathedral Rock—for backgrounds, even in black-and-white. Many were Westerns, like *Angel and the Badman*, John Wayne's first film as producer. Most of the big stars of the time have worked here, including Henry Fonda, Glenn Ford, Burt Lancaster, and Elvis Presley. Some TV shows and many commercials are still shot here. (Sedona Historical Society.)

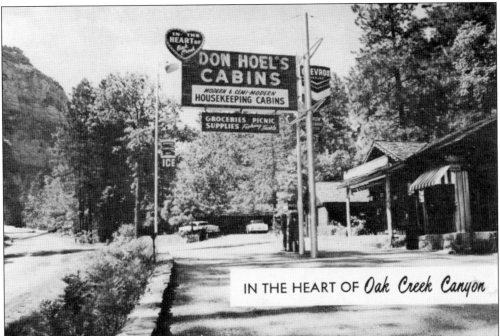

Sedona's early industries—cattle ranching, orchards, and motion pictures—have largely been replaced by art galleries and tourism. The tourism trend started in the 1920s with the movie industry and has grown continuously since then. Today, Sedona hosts millions of visitors each year. Here, Don Hoel's Cabins on Highway 89A are shown in 1962. (Advertising brochure.)

Sedona was divided between two county governments until 1987, when residents voted to incorporate as a city. Sedona has its own municipal government and has won two state awards for community planning. Standards for development, landscaping, and signage have resulted in attractive streetscapes and open space. Uptown Sedona caters to the tourist trade with fine restaurants, galleries and shops, Pink Jeep Tours, and resort hotels. (Sedona Historical Society.)

Eight

ALL AROUND
YAVAPAI COUNTY

The 34-year period from 1864 to 1898 was a time of growth and industry for the Prescott area. Mining, lumbering, and livestock operations, the mainstays of early Yavapai County commerce, left the surrounding land deforested, overgrazed, and pocked with mining hazards and toxic materials. Protection from these abuses was necessary, and a clean surrounding watershed was important to producing an abundant and healthy water supply. At the request of Prescott city officials, the Prescott Forest Reserve was established by Pres. William McKinley on May 10, 1898.

By statehood in 1912, Prescott Forest Reserve had been renamed the Prescott National Forest and was managed by the fledgling US Forest Service. Expansion along the Bradshaw Mountains to the south and the Juniper Mountains to the north, including the Verde National Forest, totaled approximately 1.25 million acres, the size of the state of Delaware.

Names of places such as Grief Hill, Yellowjacket Gulch, Lonesome Pocket, Blind Indian Creek, and Battle Flat tell of past events and harsher times. Portions of the forest today are much the same as they were when Sam Miller of the Walker party reached for gold on Lynx Creek and was wounded by a wildcat, or when General Crook's flag of command fluttered over Palace Station in the Bradshaw Mountains south of Prescott.

Watershed protection and water issues continue to be important to Yavapai County. The headwaters of the Verde, Aqua Fria, and Hassayampa Rivers originate in the Prescott National Forest. Important tributaries include Walnut, Pine, Granite, Lynx, Big Bug, and Sycamore Creeks.

Plant and terrain features are diverse. High, cool peaks of the Bradshaw and Mingus Mountains contrast with the sun-baked Sonoran Desert below. In between, desert grasslands, chaparral, canyon hardwoods, pinion and juniper woodlands, and vast stands of ponderosa pine offer varying landscapes, vistas, wildlife habitat, and recreation opportunities. Prehistoric and historic sites are abundant. Lynx Creek Ruin, Palace Station, Horsethief Basin, and Walnut Creek Ranger Station are examples.

The Prescott National Forest—its resources, places, people, and events—is truly woven into the colorful fabric of Yavapai County history.

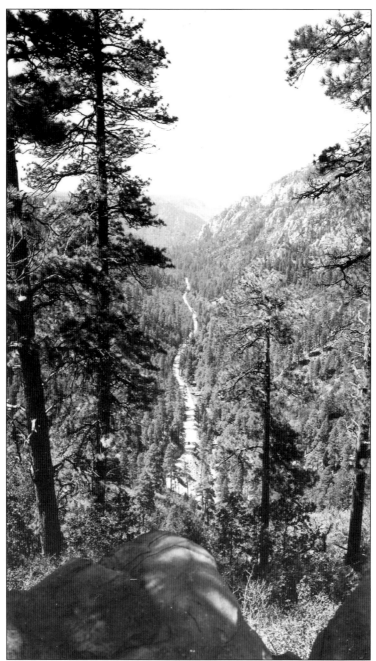

Comprising about 1.25 million acres, Prescott National Forest borders three other national forests in Arizona—Kaibab, Coconino, and Tonto. Roughly half of the forest lies west of Prescott in the Juniper, Santa Maria, Sierra Prieta, and Bradshaw Mountains. The other half lies east of Prescott in the Black Hills, Mingus Mountain, Black Mesa, and the headwaters of the Verde River. Portions of the Prescott National Forest are much the same today as they were when Sam Miller panned for gold in Lynx Creek or when General Crook's flag fluttered over Palace Station. The Prescott National Forest provides over a million acres of recreational opportunities practically outside the doorsteps of local residents. (Sharlot Hall Museum.)

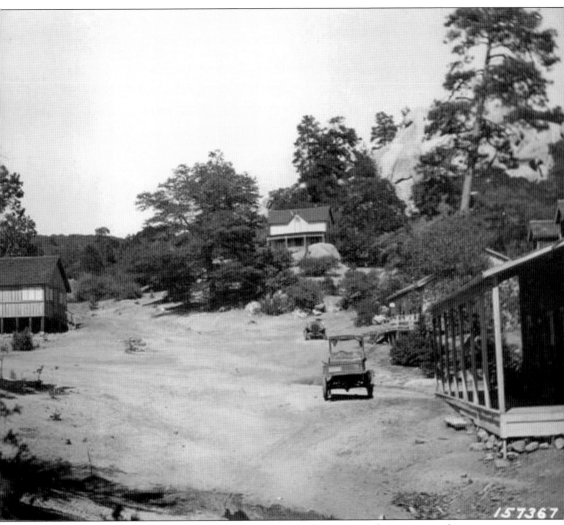

This image shows the main plaza of the Iron Springs Recreational Area six miles or so east-northeast of Prescott along County Road 10. To encourage the use of Prescott National Forest, private summer cabins were allowed to be built on Forest Service land. This is the origin of the Iron Springs Community, now privately owned, adjacent to the Iron Spring Railroad stop. (USDA Forest Service.)

A 1935 act of Congress required the Prescott National Forest to set aside an area to be developed by the City of Phoenix approximately eight miles southeast of Crown King. This store was built by the City of Phoenix in 1937 at the Horsethief Basin Recreation Area. Other facilities included summer cabins, an octagonal dance hall, tennis courts, and campgrounds. (USDA Forest Service.)

The Federal Emergency Relief Act established various work programs during the Great Depression. Prescott National Forest hosted permanent and transient Civilian Conservation Corps (CCC) camps. This is the Perkinsville Transient Camp approximately 20 miles northeast of Chino Valley on County Road 70. The Mess Hall is shown in the center of the photograph. No facilities currently exist at this location. (USDA Forest Service.)

Ranger stations and guard stations in Prescott National Forest were used as offices, housing, fire stations, equipment storage, and livestock corrals and facilities. This is the Yaeger Canyon Ranger Station Office adjacent to Highway 89A about 12 miles east of the junction with Highway 89 on the route from Prescott to Jerome. (USDA Forest Service.)

GRANITE MOUNTAIN AT THE BASIN PRESCOTT, ARIZONA

Granite Basin Lake sits at the base of the rugged Granite Mountain Wilderness Area just west of Prescott. Ponderosa pines, junipers, manzanitas, and granite boulders make up some of the scenic beauty of the area. Because it is all in the Prescott National Forest, the area has seen little change since this photograph was taken in the 1940s. (L.L. Cook Co. RPPC.)

Nine

YAVAPAI-PRESCOTT INDIAN TRIBE

The Yavapai-Prescott Indian Tribe, one of three Yavapai tribes, has a unique place in the history of the Southwest dating back to the prehistory of this region of North America. For thousands of years, the Yavapai lived within a territory encompassing more than nine million acres, including what is now known as central and western Arizona. At one time, there were four divisions of the Yavapai, but they considered themselves to be one people who spoke the same language and shared the same beliefs and customs.

Except for skirmishes with bordering tribes, the Yavapai lived in peace. Prior to the 1860s, the Yavapai homelands supported several thousand members of the tribe, but rapid changes to their lifestyle began to occur as settlers and miners invaded their homelands in the early 1840s. At first, the Yavapai sought to live alongside the newcomers in peace, but the Anglos mistakenly identified them as Apaches and attacked the Yavapai at every opportunity. As a result, the Yavapai could no longer move about freely in search of game and shelter.

During the years that followed, the Yavapai tried to fight back, and efforts to relocate them were futile because of inadequate food supplies. Many more were killed in the continuing skirmishes between the settlers and the Indians. During an 1875 march to relocate the Yavapai to the San Carlos Indian Reservation, the lives of more than 115 Yavapai men, women, and children were lost. In the early 1900s, some returned to the Prescott area and joined those who had escaped the march, and they settled once again in their homeland near Fort Whipple. Their numbers were significantly decreased, but they were determined to carry on their legacy and appointed Sam Jimulla their chief. When he died, his wife, Viola, succeeded him. As a result of her leadership, she is honored in the Arizona Women's Hall of Fame.

Because of land transferred to the tribe from the old Fort Whipple Military Reserve by the US government, many Yavapai now reside on a reservation in Prescott encompassing nearly 1,400 acres. The tribe owns and operates a hotel, two casinos, and a shopping center.

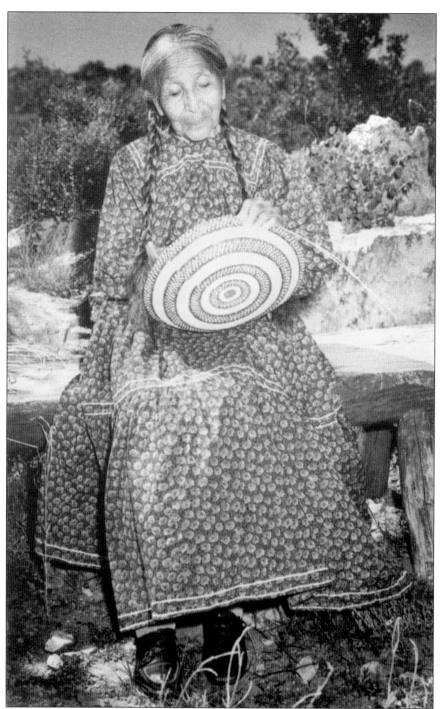

When Chief Sam Jimulla died in 1940, he was succeeded by his wife, Viola. A devout Christian, she organized the first Indian Presbyterian Mission. She is also known for her talent as a weaver of fine baskets. The only female chief among North American Indians at the time, Viola died in 1966 at 88 years old. She was greatly admired and many Arizonans mourned her death. (Sharlot Hall Museum.)

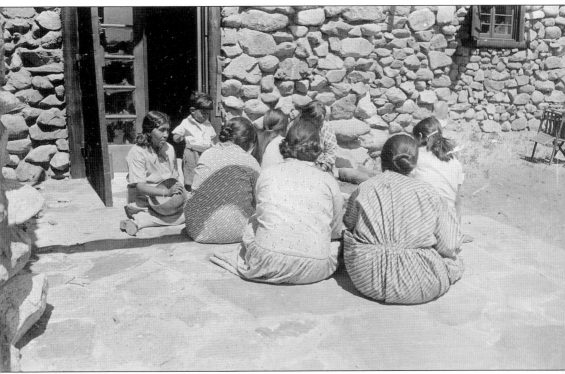

The Yavapai Indians' talent for creating beautiful baskets with designs that tell stories is recognized worldwide, and today the descendants of these weavers seated in front of the Tribal Community Building focus on recovering and preserving the artistry of their ancestors. (Sharlot Hall Museum.)

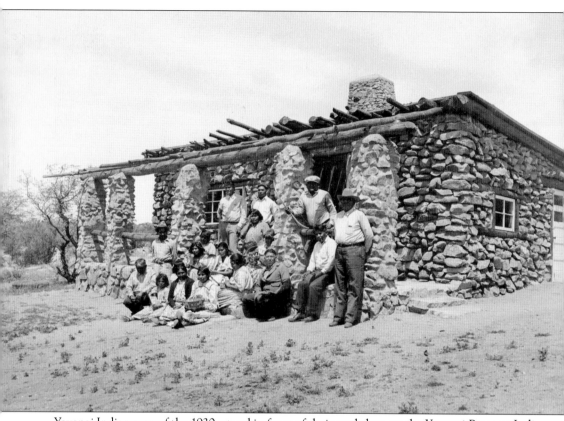

Yavapai Indian men of the 1930s stand in front of their workshop on the Yavapai-Prescott Indian Reservation. The Reconstruction Finance Corporation Act for relief work efforts during the Great Depression was likely the initial source of money to build this workshop, made of logs from the national forest and native stone hauled by the Yavapai people. (Sharlot Hall Museum.)

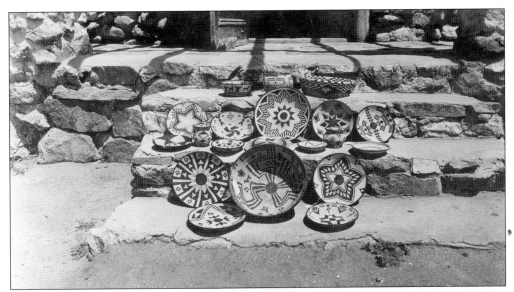

In this undated photograph, Yavapai Indian baskets are displayed for sale to tourists on the front steps of the Tribal Community Building on the Yavapai-Prescott Tribe's reservation. (Sharlot Hall Museum.)

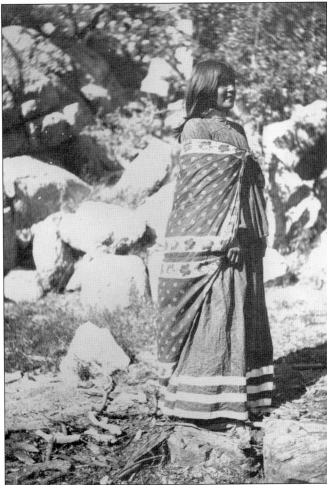

A Yavapai Indian woman poses in native dress in 1910. After Anglo contact, they wore a combination of skirts and blouses and adorned themselves with beads and necklaces, bracelets, and earrings. (Sharlot Hall Museum.)

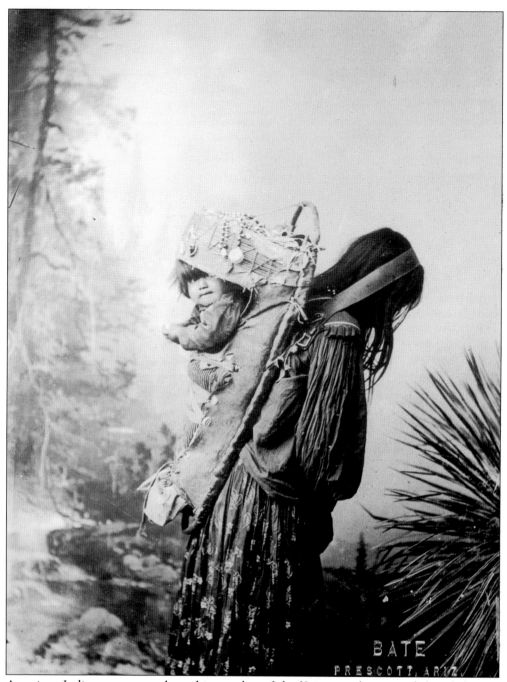

American Indian women, such as this member of the Yavapai tribe, carried their babies in cradleboards to keep them safe and comfortable. Cradleboards allowed the women to work and travel, knowing their infants were secure. (Sharlot Hall Museum.)

Ten

YAVAPAI-APACHE NATION

The Yavapai-Apache Nation (YAN) is the modern amalgamation of two ancient tribes, the Yavapai and the Dilzhe'e (Tonto) Apache. Both groups called what are now Yavapai and Coconino Counties home for centuries prior to Euro-American culture coming to Arizona. Yavapai people are a part of the Yuman language family, while Apache people belong to the Nadene/Athabaskan family of languages. Both people hunted, gathered, and grew corn and melons at the mouths of canyons and along streams throughout central Arizona. Water was respected more than any other resource as the source of life in the desert, especially where it emanates directly from the earth, as it does at the Verde Springs or Montezuma's Well.

Soon after their homelands were confiscated by the US government, the Yavapai and Dilzhe'e people were force-marched in the winter of 1875 to the concentration camp at San Carlos, where they remained in exile for a generation. By 1895, many of the people began returning to their old homes only to find the land and springs occupied by the newcomers. These stalwart few who returned home became the nucleus for the two independent tribes in Camp Verde and Prescott today.

In 1936, the Yavapai-Apache people of the Verde Valley were recognized by the US government as a sovereign nation. The last century has been a struggle to adjust to the new economy, culture, and government, but it has paid off. Today, the Yavapai-Apache Nation in Camp Verde owns and operates Cliff Castle Casino and sends its people to college and into military service. The Yavapai-Apache community is moving forward with its feet solidly planted in the heritage of Yavapai County and its eyes on the future.

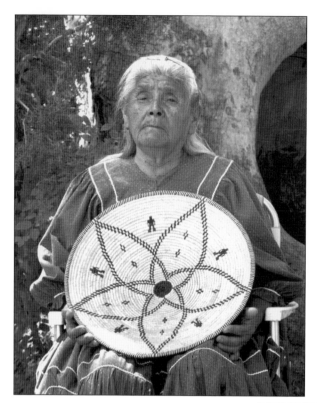

Virginia Smith-Newton was born in Fossil Creek in 1916 and lived most of her life in Camp Verde. Virginia was the last of the "complete" Apache basket weavers—she gathered and processed her own materials before turning them into finely woven bowls, water jars (*tus*), plates, burden baskets, and miniatures. She was fluent in Apache, and it remained her chosen language until her passing in 2006. (Yavapai Apache Nation.)

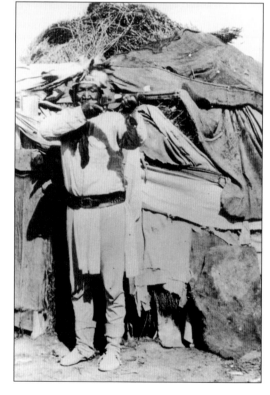

Esmale, aka Captain Smiley, born on the future Cottonwood townsite around 1835, belonged to the Apache clan Yah Go Hi' Gain (White Lands Coming Down). Esmale enlisted in Army Company B, Indian Scouts, and was on the campaign when Geronimo and his Chiricahua Apaches surrendered for the final time. He received a government pension and lived in Camp Verde until his death. (Yavapai Apache Nation.)

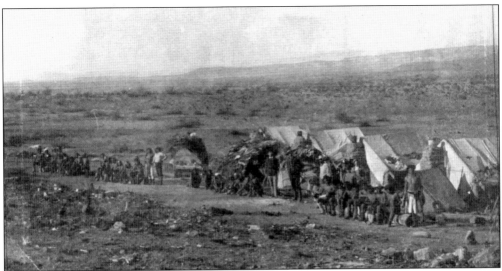

Indian Scouts of Company B are shown on parade at Camp Verde around 1876. Most of these men were Apache, with a handful of Yavapai from the Verde Valley. They received federal pay, rations, a rifle, and all the action they could handle. They were used by Generals Crook and Miles with deadly effect to run down Geronimo in Mexico in the 1880s. (Yavapai Apache Nation.)

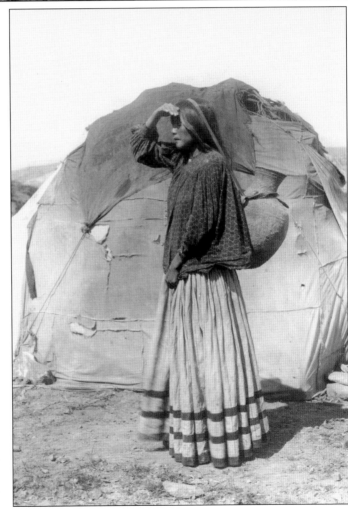

An Apache woman is carrying a water jar around 1900. This is a traditional method of hauling all manner of materials, from water and gathered foods to firewood, by a tumpline around the forehead— leaving both hands free for other tasks. Women carried toddlers and infants in a cradleboard or a sling wrapped around their front. (Yavapai Apache Nation.)

Discover Thousands of Local History Books Featuring Millions of Vintage Images

Arcadia Publishing, the leading local history publisher in the United States, is committed to making history accessible and meaningful through publishing books that celebrate and preserve the heritage of America's people and places.

Find more books like this at
www.arcadiapublishing.com

Search for your hometown history, your old stomping grounds, and even your favorite sports team.